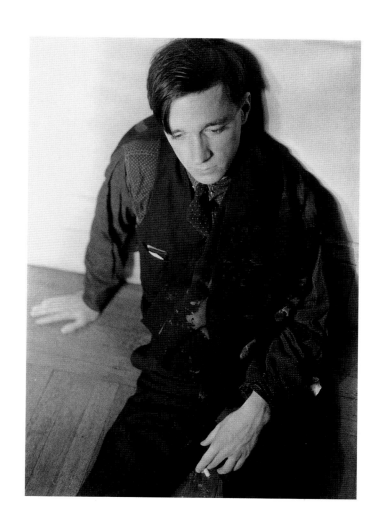

Illustration page 1:
Self-portrait, 1930–32, 17.1 x 11.7 cm
The Metropolitan Museum of Art, Purchase, Various Donors 1998.145

Unclassified
A Walker Evans Anthology

Selections from the Walker Evans Archive

Department of Photographs

The Metropolitan Museum of Art

Jeff L. Rosenheim and Douglas Eklund

Edited by Jeff L. Rosenheim in collaboration with Alexis Schwarzenbach

With an introduction by Maria Morris Hambourg

Scalo Zurich—Berlin—New York

in association with

The Metropolitan Museum of Art, New York

Contents

Introduction

Walker Evans (1903–1975) scarcely needs introduction. This American photographer whose working life spanned fifty years in the middle of the 20th century is the poet laureate of the documentary style. Consciously or not we have absorbed his iconic images which have worked on the chromosomes of our consciousness to become a blood heritage. His portrait of Allie Mae Burroughs is the face of the Great Depression, his white board church is the purest southern distillate, his tools are the ur-versions, his Broadway the only street, his child's grave the most final.

Evans is not only present in the cultural genes of the general public; for visual artists who have matured since the 1960s he has been so often a model that his photographic idiom is virtually an artistic *lingua franca*. His social surveillance method, cool detached vision, and interest in vernacular culture are basic to the vision of such artists as Andy Warhol, Ed Ruscha, Chuck Close, Sol LeWitt, Dan Graham, Robert Venturi, Nick Nixon, Cindy Sherman, Bernd and Hilla Becher, Thomas Struth, Hiroshi Sugimoto, Sophie Calle, and Patrick Faigenbaum, to name only a few. An important mentor to Robert Frank, Diane Arbus, and Lee Friedlander when he was an editor at *Fortune* magazine from 1945 to 1965, Evans also influenced scores of students when he taught at Yale University in the 1960s.

This powerful and enduring influence was underpinned by many factors. First, and most obviously, Evans had excellent exposure: The Museum of Modern Art in New York championed him from the 1930s, effectively making his vision a central tenet of the history of modern art. The more important reasons lie with the work itself. The artistic solutions Evans devised are simple and easy to repeat; his techniques were mechanically based and involved no darkroom wizardry or privileged apprenticeship. Also, because Evans

grasped—as few had before—that mass production is a basic condition of modernity, his work demonstrates how seriality, multiplicity, and the media are implicit in every aspect of our lives. This prescient view has proved ever more relevant in the electronic age. Third, he sensed that the timbre of the time was conveyed with a peculiar authenticity through vernacular things rather than formal or academic expressions, and he therefore made a habit of studying billboards, roadside stands, wrecked cars, rural churches, graffiti and trash for signal significance. Shifting attention from the ideal to the ordinary, he leveled the landscape of art. As Lee Friedlander put it: "[Evans] made it possible for photographers who came after him to believe that anything was possible, anything could be interesting, anything could be beautiful." Similarly, Evans also saw that it was not the stars in their newsworthiness but the ordinary people in their anonymity who were the proper measure of man.

The intellectual rigor of Evans's method shines like a searchlight far beyond the usual fickle circles of fame. He addressed the largest issues—work, tradition, death, religion, race, and community—by focussing on specific facts carefully selected and weighed for their telling value as illustrations of a facet of his larger concept, a contemporary *Comédie Humaine*. Developing his œuvre over several repeating themes, he was a conceptual artist *avant la lettre*, a mordant and concise Balzac who intended nothing less than a portrait of the modern world in the making.

Indeed, the scope of Evans's work and his ways of dealing with his subjects were born from a deep love of literature as well as from a fascination with the mass-produced image. Born in 1903 in the American Midwest to an advertising executive and a housewife and raised in the elite Chicago suburb of Kenilworth and the industrial city of Toledo, the boy demonstrated early talent in English and in photography. Growing up in a world already papered with pictures, this child of the media age also began what would eventually

become his impressive collection of photographic postcards. Moving to East Coast schools in 1919, the rebellious adolescent became seriously addicted to modern English and French literature, subversive guides to living outside the Establishment according to one's personal code. He devoured Eliot, Joyce, and Hemingway as their works issued from the presses, and in 1926–27 he traveled abroad and lived in Paris to walk the sidewalks of Baudelaire, Flaubert, and Proust, refine his French, haunt the fabled bookstore Shakespeare and Company, and try to write.

Evans was in fact an *homme de lettres*, a serious reader and book collector all his life and ultimately an excellent writer. From his close study of literature he learned a form of extra-sensitive, disinterested social observation, as well as particular techniques for disappearing within the authorial role, for grasping the essence from the detail, and for revealing delicious ironies, parallels, and reversals within a given scene. His intense admiration for the highest standards of art combined with his own youthful inexperience, however, caused such acute self-doubt that he destroyed much of his early writing. He returned to New York with all the experience he needed to become a great author, a few surviving manuscripts, a handful of snapshots, and a bad case of writer's block.

The incapacitating self-consciousness vanished when Evans indulged his "left-handed hobby" and went out for a stroll with a camera. As photography quickly proved to be a more productive outlet for his creative urges than writing, he became obsessed with its potential. Although he continued to translate from the French, write the occasional short story and carry on a remarkably wide correspondence, he was actually pouring his accumulated passions, literary skills, and acute perceptions—not to mention his enormous ambitions—into photography. This remarkable and historic transition is visible for the first time in this volume.

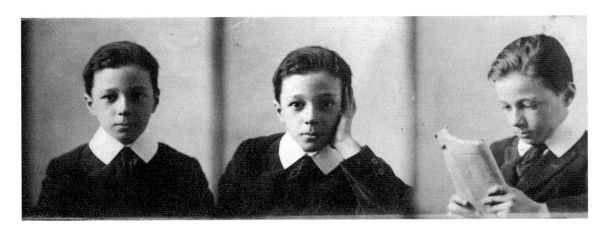

Unknown Photographer, [Walker Evans], 1911–13, 3.2 x 8.4 cm
The Metropolitan Museum of Art, Purchase, The Horace W. Goldsmith Foundation Gift 1996.166.11

When Evans decided to make a career of photography in 1930, he studied his options with care. He rejected what he saw as the subjective, vaporous ideas of Alfred Stieglitz, the patriarch of American art photographers, and he also rejected advertising photography, which served the wrong gods. In "The Reappearance of Photography," an article he wrote in 1931, he summarized his opinions. Skewering art photography (a veiled stab at Stieglitz) and commercial photography as represented by Edward Steichen's slick work, he gave high praise only to August Sander, who documented German society objectively, and to Eugène Atget, who had documented Paris so poetically. He also applauded the European vogue for scientific and news photographs. All these documents emanated straight truths that attracted him like lodestones. The unflinching realism of Paul Strand's portrait of a blind street peddler and the gritty newsreels he watched every week in a Times Square theater also impressed him. Amalgamating these visual sources and inflecting them with the literary techniques he had been studying, Evans evolved his "documentary style," a seemingly artless presentation of real life in pictures as legible and self-evident as illustrations in a dictionary.

Besides his "styleless" style, Evans's other great legacy was the importance he revealed in the vernacular not only as an artistic vehicle but also as an encyclopedia of popular notions. While this appreciation was expressed in many of the subjects he collected with a camera, Evans's interest in the vernacular is most completely demonstrated in his material collections. The picture postcards he amassed throughout his life, the engravings and rotogravure images he clipped from the picture press and especially the remarkable album he composed of them, his picture stories for *Fortune*, the signs he brought home to decorate his walls, and the collection of instant snapshots he made late in life are all manifestations of his unquenchable appetite for the anonymous and mass-produced, for art of, by, and for the people.

At the time of his death in 1975 the trove of material Evans had edited from the world—a half century of sifting for true meanings and hidden beauties—was intact in his Connecticut home. In 1994 The Metropolitan Museum of Art received a donation of the artist's collections, negative file, library, papers and copyright through the good offices of the artist's executor and the generosity of his heirs. Previously unavailable to the interested public, his treasure house of material is now unclassified.

This volume of selections from the Walker Evans Archive delves into all the important pockets of the artist's creativity, allowing the reader to watch as he shapes his raw materials and refines and transposes his ideas from words to pictures and back again. Most of the items are published here for the first time: the pages from the family albums, many of the manuscripts, lists, literary sketches, and letters, also most of the pictures and collected items—all of which allow one to witness that most fascinating and mysterious activity, the inner workings of the artist's mind.

The selections were made, introduced, and annotated by Jeff L. Rosenheim and Douglas Eklund, Assistant Curator and Senior Research Assistant

in the Department of Photographs at The Metropolitan Museum of Art. Over the past five years they have studied, cataloged, and overseen the conservation of thousands of objects and as a result of their efforts and the kind support of the many foundations, individuals, and institutions elsewhere acknowledged, the Walker Evans Archive in the Department of Photographs is open to the public by appointment. Through this publication we hope to encourage others to study its rich contents further and perhaps to mine the vast potential of their own surroundings by following an unequaled artist and master of minutiae in his exacting search for the best example and the better solution.

Maria Morris Hambourg
Curator in Charge
Department of Photographs
The Metropolitan Museum of Art

Note to the Reader

All photographic works reproduced in this book are by Walker Evans, unless noted otherwise, and are gelatin silver prints, unless described differently. For many of his photographs, Evans provided original titles, which are given here. For untitled works, descriptive titles are provided in brackets.

Unless noted otherwise, all reproductions in this publication are in the collection of The Metropolitan Museum of Art, New York. Most are in the Walker Evans Archive (WEA), acquired by The Metropolitan Museum in 1994. All reproductions of photographs credited to the WEA with the prefix 1994.251–259 are of modern prints produced from Evans's negatives expressly for this book.

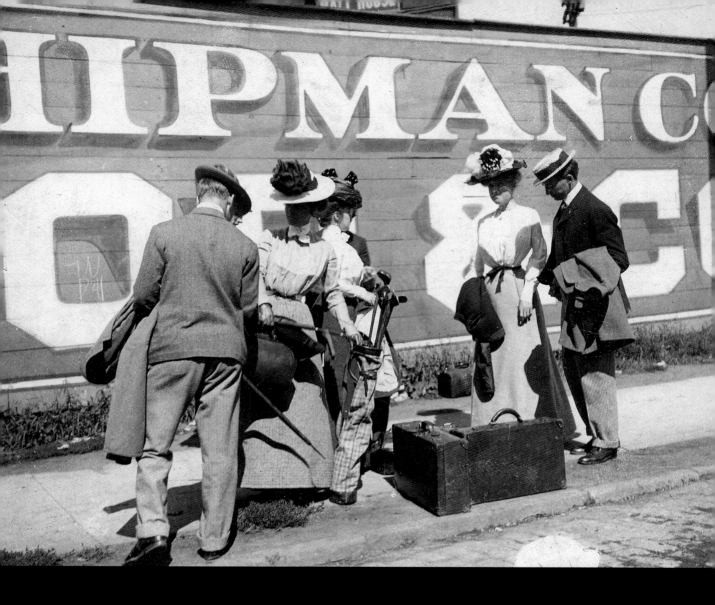

Family Albums

1898–1916

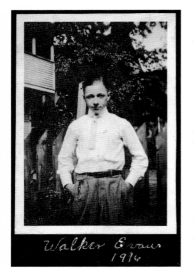

Walker Evans carefully preserved three albums of family photographs. The earliest album was compiled by Evans's mother, Jessie Beach Crane, and dates from June to November 1898, two years before she married Evans's father Walker Evans Jr. in St. Louis, Missouri. The other two albums date from 1910–1916 and 1905–1916 and were respectively put together by Evans and his sister Jane who was one year older. Variants of the same photographs appear in the siblings' albums, both of which are disbound.

The albums reveal that the Evans and Crane families took their leisure pursuits seriously: tennis and golf matches, and sailing trips in the Great Lakes and off the coast of Maine are all documented alongside Christmas visits with grandparents and afternoon football games with friends. A collection of related but loose photographs include informal views of immediate family and friends in Missouri, Illinois, Michigan, Montana, and Ohio as well as more formal portraits—*cartes-de-visite*, ambrotypes and tintypes—of Evans's antecedents from the Civil War era through to the end of the century.

The family photographs document a fairly typical, educated, upper middle-class, mid-western urban existence in the two decades before World War I. Evans's father worked in advertising and was the son of three generations of Missourians. Little is known about the Crane family or their business professions except that Evans's mother was born in Missouri but had family in both Massachusetts and South Carolina.

Like most Americans born after the Kodak camera was introduced in the late 1880s, Evans grew up in a world in which photography was an integral aspect of domestic life. Evans's album shows that even as a child he was at times granted or perhaps simply assumed the role of family photographer,

archivist, and documentarian. His earliest photographic works show Evans's nascent talent as a photographer, editor, and graphic designer, while the annotations on the album pages are his first efforts at picture titling.

Perhaps it is too much to suggest that Evans's career in art began in early childhood. The truth is, however, that most American photographers born in the first years of the 20th century had a similar experience. Photographs were common currency which inevitably some valued more than others. One proof that Evans had a special appreciation for his family photographs is a family snapshot from 1898 (p. 14). The photograph depicts his parents and friends with their luggage and golf clubs on a Detroit street. A discarded variant of a photograph his mother selected for her album, the scene is chaotic and neither of his parents' faces is visible.

The photograph's failure as a useful album portrait did not keep Evans from seeing its success as an image rich in photographic description and slightly comic graphic disharmony. He clearly valued the remarkable collage of street portraiture and signage—two of his most enduring camera subjects; moreover, he mounted the photograph on the special board he used in 1928–30 for his first successful photographs, elevating a snapshot from the family archive into an appreciable work of graphic art.

Two photographs from the family album of Walker Evans's mother, Jessie Crane Evans

[Jessie Crane (middle) Embracing Walker Evans, Jr.], 1898, 10 x 12.1 cm, WEA 1994.261.192

[Walker Evans, Jr., Jessie Crane, and Unidentified Men], 1898, 10.1 x 12.2 cm, WEA 1994.261.192

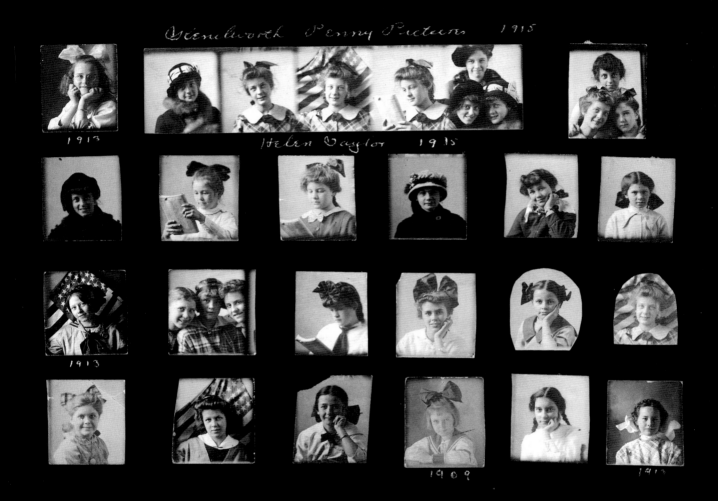

Two pages from Jane Evans's family album, [two portraits of Walker Evans, far right, bottom row of second page]
Unknown Photographers, *Kenilworth Penny Pictures, 1915*, 17.7 x 28.3 cm, WEA 1994.261.193

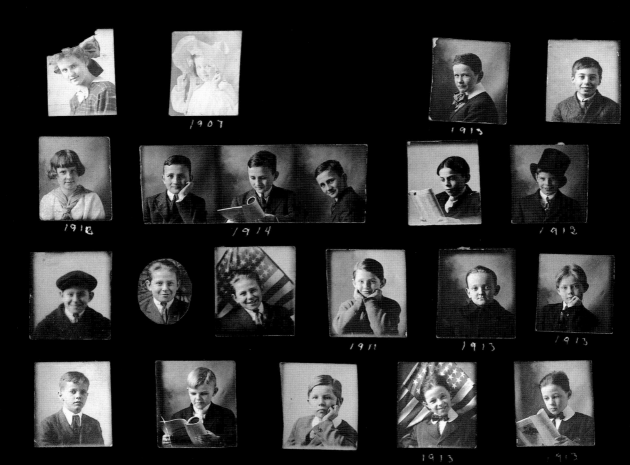

1907

1913

1910 1914 1913

1911 1913 1913

1913 1913

Mother and Farther at Toledo in Nov, 1915

Back of House on Winthrop street. 1 9 1 5

Albert, our Butler and Chaufera 1 9 1 5

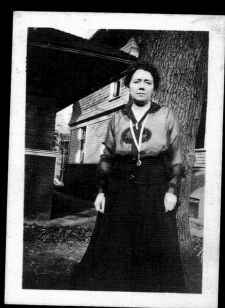

mother, 1915

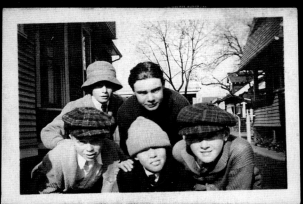

E.M., E.G., G.S., E.H. and "Jess"
1 9 1 5

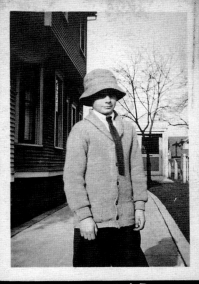

"E.D.", 1915

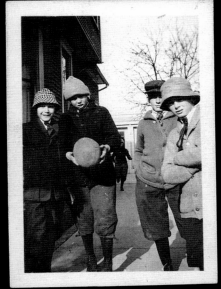

G.B., E.H., "Jess," E.M.
1 9 1 5

G.S., H.V., E.H.

T.L., E.H., H.V.

UNCLE RALH
AT
HAMILTON,
MONT.
1916

GRANDFATHER'S HOUSE
AT
WINNETKA,
ILLINOIS.

pair of pants
Hamilton, Montana,
Summer, 1916

Dogs and cats at Hamilton
1916

changing the design. This ~~flew~~ threw me

into indescribable delights. I still ~~recall~~

~~the~~ distinctly recall the color and form

of the ~~crystal~~ glass scenes: the largest

piece was clear ruby; it was triangular

in form; its weight led it first and ~~beyond~~ over

the rest which it upset. There was a very

dark and almost round garnet ~~garnet~~; a blade-like ~~an~~

emerald ~~crystal and fain~~; a topaze

of which I recall only the color; a sapphire

and three little ~~golden~~ golden brown

left-overs. They were never all in sight

at once; certain ones stayed completely

hidden; others half out of sight ~~at~~ the far edges

on the other side of the mirrors; the ruby

alone, too important, never entirely dis-

appeared.

Page from Walker Evans's translation of André Gide's *Si le grain ne meurt*, manuscript, Florence, April 17, 1927

WEA 1994.250.1 (24)

My cousins, who shared my ~~taste~~ liking

for this game but ~~were~~ showed less

patience in it, would shake the instrument

Writings
1924–1969

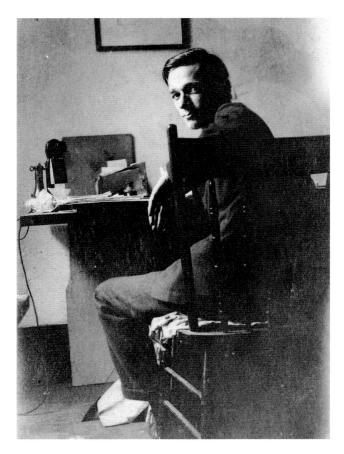

Hanns Skolle (American, born Germany,
1903–1988), [Walker Evans, New York City],
June 1927, 5.7 x 3.9 cm
WEA 1994.261.24

Walker Evans's first love was literature. Although he would express himself primarily in photographs, writing remained an important creative outlet all his life. Beginning in 1924 and continuing for fifty years, Evans wrote short stories, prose poems, and criticism, translated essays from nineteenth- and twentieth-century French literature, and wrote short articles to accompany his photographs in *Fortune*, *Harper's Bazaar*, *Architectural Forum*, and numerous other magazines.

Translations from French 1924–1929

After dropping out of Williams College in Williamstown, Massachusetts at the end of his freshman year, Evans moved to New York in the summer of 1923. He worked in a French language bookstore and at the New York Public Library which insured him access to avant-garde magazines and recently published modern literature. By the summer of 1924, if not before, Evans was translating French essays into English. In 1926 he moved to France where he enrolled in language and civilization courses at the Sorbonne and at the Collège de la Guild in Paris continuing his translations and refining his French through assigned essays. As French seemed the language of serious literature to Evans, his early translations provide important clues not only to his personal tastes but also to his aesthetic ambitions.

Evans's first surviving work as a writer is the translation of a section of *The French Book in America*, (1909) by Rémy de Gourmont (1858–1915), an author whose novels, prose, and criticism played a significant role in disseminating Symbolist aesthetics. Evans was evidently of one mind with Gourmont: he criticized American literary conservatism yet appreciated the inspired readers (like himself) who welcomed French books and studied them thoughtfully. Until 1929 Evans went on to translate Baudelaire, Le Comte de Lautréamont (Isidore-Lucien Ducasse), Gourmont, Raymond Radiguet, Jean Cocteau, André Gide, Valéry Larbaud, and Blaise Cendrars.

[Courtyard of 5, Rue de la Santé, Paris], August 1926, 6 x 3.9 cm
WEA 1994.261.1

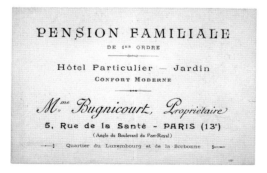

[Card for pension familiale at 5, Rue de la Santé, Paris], 1920s, engraving, 7.8 x 11.9 cm
WEA 1994.250.91 (24)

Charles Baudelaire (1821–1867)
"La Chambre double," from *Petits Poèmes en prose*

Paris: Michel Lévy frères, 1869
Translated in Paris, August 1926
Typescript
WEA 1994.250.1 (4)

In August 1926 after two months in Paris, Evans translated two short poems from Baudelaire's ground-breaking *Petits Poèmes en prose:* "A Une Heure du matin" and "La Chambre double." From Baudelaire Evans learned that to be modern one had to be in daily contact with the ephemera of urban life, as a spectator alone, yet at home, in the street. As a photographer he would soon incorporate the role of the intelligent observer into the very core of his art by focusing his camera on the popular culture of his era—on anonymous urban types and their collective desires, on their homes and automobiles, and on the tangible products of their work.

The survival of these translations substantiates Evans's claim that one of his characteristic aesthetic methods—dependence on detached observation— was an idea taken directly from his early reading of Baudelaire. That Evans was unafraid of tackling the great Baudelaire, and that he tried to equal him in his perfectionism, indicates the degree of refinement he had already acquired in his writing and in his natural identification with the interior monologue.

THE DOUBLE ROOM

A room which resembles a day-dream, a room ver-
itably <u>intelligent</u>, in which the stagnant atmosphere
is lightly tinted with rose and blue.

Here the soul bathes in laziness flavored with
regret and desire - there is something of the fall
of days, blueish, roselike; a dream of voluptuous-
ness during an eclipse.

The furnishings are lengthened forms, dejected,
weakened. They seem to dream; one would say they
were gifted with a somnambulistic life, as is veg-
etable or mineral matter. The materials speak a mute
language, as do flowers and skies and sunsets.

On the walls, no artistic abomination. In compar-
ison to pure dream, to unanalysed impression, definite
art, positive art, is blasphemy. Here, everything has
the adequate clarity of harmony's delicious obscurity.

An infinitesimal fragrance of the most exquisite
sort, with which is mixed a very slight humidity, swims
in this atmosphere where the slumbering spirit is
lulled by hot-house sensations.

Muslin weeps copiously before the windows and over
the bed; it falls in snowy cascades. On the bed lies
the Idol, the sovereign princess of dreams. But how
is she come here? Who has brought her? what magic pow-
er has installed her on this throne of reverie and
voluptuousness? What does it matter? There she is!
I recognize her.

There indeed are those eyes whose flame penetrates
the dusk; those subtile and terrible little _mirrors_
which I know by their frightful maliciousness. They
attract, they subjugate, they devour the glance of the
imprudent one who contemplates them. I have often
studied them, those black stars which command cur-
iosity and admiration.

To what benevolent demon do I owe this being sur-
rounded with mystery, silence, peace, and perfumes?
Oh bliss! What we know as life, even in its happiest
expansion, has nothing in common with this supreme
existence which I now know, and which I savor minute
by minute, second by second!

No! there are no more minutes, there are no more
seconds! Time has disappeared; Eternity reigns, an
eternity of delights!

But a terrible knocking resounded upon the door,
and, as in infernal dreams, it seemed to me that I
was receiving an axe-blow in the stomach.

And then a Spectre entered. An officer come to
torture me in the name of the law; an infamous con-
cubine come to cry misery, to add the trivialities
of her life to the anguish of my own; or some editor's
errand-boy come after the continuation of a manuscript.

The heavenly room, the idol, the princess of dreams,
the _Sylph_, as the great Réné used to say, all that
magic disappeared at the brutal knock sounded by the
Spectre.

Horror! I remember! I remember! Yes! this filthy
hole, this abode of eternal ennui, is really my own
room. I see the sottish furniture, dusty and broken-
down; the fireplace without fire or coals, tarnished
with spittle; the sad windows, on which the rain has
traced streaks in the dust; manuscripts, scratched
over or unfinished; the calendar on which my pencil
has marked sinister dates!

And this perfume of another world with I intoxicated myself with such perfected sensitiveness, alas! it is replaced by a fetid odor of tobacco mixed with I don't know what nauseous mustiness. Now one breathes here deiolation's spoil.

In this narrow world, narrow but so full of disgust, a single object smiles at me: the phial of laudanum; an old and terrible friend; like all friends, alas! full of caresses and of treachery.

Ah! Yes! Time has reappeared; Time rules all now; and with the hideous dotard has returned all its devilish retinue of remembrances, regrets, spasms, fears, anguish, nightmares, rages, neurosis.

I assure you that now the seconds are strongly and solemnly accentuated, and each one, as it leaps from the clock, says: "I am Life, insupportable, implacable Life!"

There is but one second in human life which has the power to announce good tidings, the <u>good tidings</u> which cause an inexplicable fear to all.

Yes! Time reigns; it has recommenced its brutal rule. It pushes me with its two-pronged goad as if I were an ox. "Get along, there! Ass! Sweat now, slave! Live, damned one!"

 BAUDELAIRE

Paris
August, 1926

Blaise Cendrars (1887–1961)
"Mad," selected excerpts from *Moravagine*

Paris: B. Grasset, 1926
Translated in Europe, New York and Connecticut, 1926–29
Published in *Alhambra*, August 1929
WEA 1994.250.1 (23)

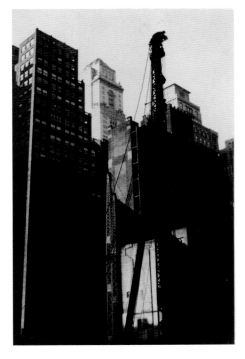

New York in the Making, 1929, 9.4 x 5.7 cm
The Metropolitan Museum of Art, Gift of Arnold H. Crane 1971.646.34

Evans began translating Blaise Cendrars's just published surrealist novel *Moravagine* while in Europe on his year abroad. The story about the wanderings of a violent psychopath and the sympathetic young medical doctor who sets him free from an asylum is a structurally complex send-up of Freudian psychology that remains difficult even for seasoned linguists to translate. In 1929 Evans was able to convince the editor Angel Flores to publish a portion of an early chapter in his short-lived New York literary monthly *Alhambra*. It was Evans's first appearance in print and the issue also included his earliest published photograph, *New York in the Making*, a view of a New York City construction site. Even though Evans later abandoned this translation project, the existing parts are remarkably agile and effective. In "Mad" the patient tells his own story—of how he was forced to kill his lover after succumbing to a "passion for objects, for inanimate things." *Moravagine*'s predicament and propensities could not have been lost on Evans, whose own ambivalence towards women was troubling and whose passion for unadorned objects would help define his life in art.

M A D
By Blaise Cendrars

Translated by Walker Evans

In "Mad" we are taken into the abysmal chaos of a crazy man's mind and shown how he murders a dog and a girl.

IN THESE moments of exaltation, everything which recalled me to reality exasperated me. Thus my poor brute of a dog, which was always following at my heels. His eyes, faithful-animal eyes, always fastened upon my own, sent me out of my wits; I found them mean, hollow, weeping, imbecile. Slyly sad. Joyless, cold sober. And that breath, that animal breath, that jerky breath, short, drawing out his flanks like an accordion, ridiculously shaking his stomach, rising and falling, as irritating as a piano exercise but never producing a note and never making an error; that unforgettable breathing! At night it filled my room. Commencing as almost nothing, it became tremendous, bombastic, grotesque. I was ashamed of it. It gave me the shivers. Sometimes, too, I was afraid of it. It seemed to me that it was I who was breathing like that, vile and poor and humiliated and needy. One day, I could stand it no longer. I called the dirty beast to me and put out his eyes, slowly, taking my time, knowingly. And then, taken with a sudden fury, I seized a heavy chair and broke it over his back. That is how I did away with my last friend. Understand me: I was forced to do it. Everything about me was out of order. My hearing. My eyes. My backbone. My skin. I was overstrained. I was in fear of going mad. So I beat him to death, like a slut from the streets. And, after all, I don't know why. But I did it, by God,

and I would do it again, if only to savor once more the sadness into which that episode threw me. Sadness, nervous upheaval, relief from all sensation. And now, call me a murderer, an inhuman creature, a savage, as you like. I don't care —because life is a truly idiotic thing.

Besides, listen to me: I have repeated that performance, the Thing, the crime, that jovial little piece of idiocy, that stroke of madness; and this time, in such a striking manner that you yourself will perhaps understand . . .

Days, weeks, months passed. I was beginning my eighteenth year when Rita came to live in one of the chateaux of the neighborhood. During that year I saw her almost every week. She came on Fridays. We spent the day in the salle d'armes, which I was particularly fond of because it was so clear and empty. Stretched out on a mattress, face to face, leaning on our elbows, we stared into each other's eyes. Sometimes, we used to go up to the second floor, where Rita played the piano in the little square salon. And sometimes, but very rarely, Rita dressed herself in old-fashioned gowns, got herself up in some ridiculous old costume which she had pulled out of one of the wardrobes, and danced out on the lawn in the bright sunlight. Then I saw her feet, her legs, her hands, her arms. Her color rose. Her neck and her breast swelled. And when she was gone, I would remain for a long time under the spell of having held her, supple

and hot and palpitating, in my arms at the moment of leave-taking. But I loved nothing so much as our long, silent intervals in the salle d'armes. A perfume of nut-shells and watercress emanated from her; in it I silently bathed myself. She did not seem to *exist* at all, you might say; she seemed to be in some way dissolved, and I absorbed her through all my pores. I drank her glances like alcohol. And, from time to time, I passed my hand through her hair.

I was the comb which galvanized her long hair. The corsage which moulded her breast. The transparent tulle of her sleeves. The dress undulating about her limbs. It was the little silk stocking; the heels she was wearing; the exquisite ruffle; the candid pompadour over her forehead. The salt of her armpits made me hoarse. I made myself into a sponge, in order to freshen the moist parts of her body. I made myself triangular and iodized. Humid and tender. Then, I made myself into a hand in order to unfasten her skirt at the waist. I was her chair, her mirror, her bath. Like a wave, I possessed every part of her completely. I was her bed.

I do not know how my looks told her all this; but quite often, I hypnotized her without meaning to do so, without knowing it.

I wanted to see her naked. I told her so, one day. She never wanted to allow it. She began to come less frequently.

Without her, deprived of her weekly presence, which I could not do without, I grew nervous, susceptible, and melancholy. I could no longer sleep at night. Carnal visions pursued me. Women surrounded me, women of all sizes and colors, of all ages and of all epochs. They lined up in front of me, rigid, like the pipes of an organ. They arranged themselves in a circle, lying down, upside down, lascivious stringed instruments. I mastered them all, arousing some by a look and others by a gesture. Standing, straightened like an orchestra conductor, I beat time for their debauches, speeding up or slowing down their transports *ad libitum;* or abruptly stopping them in order to make them start all over again thousands and thousands of times, *a capo,* to make them again go through their motions, their poses and their sporting; or dismissing them all at the same time, *tutti,* in order to throw them into a dizzy delirium. This frenzy was killing me. I was

M.

totally consumed, shrunken. Circles around my eyes, hollow cheeks. My face was lined like a sheet of music with the marks of my insomnia. Acne beat triple time on my skin, starting a measure forever uncompleted.

Goose flesh all over.

I became ashamed and timid and anguished. I did not want to see people any more. I stayed all the time in the salle d'armes; I lived there. I became very negligent of myself. No longer washed, kept my clothes on all the time. I even took pleasure in the doubtful odors of my body.

About this time, I was taken with a violent passion for objects, for inanimate things. I do not mean the utensils and the art objects with which the palace was stuffed, and which, by a sort of intellectual or sentimental exaltation, invoke, suggest, recall an old civilization, some period of the past, some faded historic or family scene; objects which charm you and captivate you by their distorted shapes, their baroque lines, their obsolete refinement, by all that places them and dates them, names, and so curiously reveals the stamp of the mode which imagined them; no; my fancy was for unaesthetic objects exclusively; unfashioned objects of coarse and elementary material. I surrounded myself with the most uncouth things. A biscuit tin, an ostrich egg, a sewing machine, a piece of quartz, a bar of lead, a stovepipe. I spent my days handling and fingering and smelling these things. I rearranged them a thousand times a day. They were my amusement and my distraction; they were to make me forget the emotional experiences which had so tired me out.

This was a great lesson to me.

Soon egg, stovepipe excited me sexually. The bar of lead had that surface so soft and warm to the touch that one finds in chamois skin. The sewing machine was like a plan or a cross-section of a courtesan, a mechanical demonstration of the force of a music-hall dancer. I should have liked to split the perfumed quartz like a pair of lips and drink the last drop of primordial nectar which the origins of life had deposited in its glassy molecules, that drop which comes and goes like some sort of an eye, like the bubble in a level. And the tin box was a reasoned summary of Woman.

The simplest figures: the circle and the square, and their projection in space; the cube and the sphere—these

(Continued on page 46)

MAD

(Continued from page 35)

moved me and spoke to my senses like vulgar signs, red and blue symbols of obscure and barbarous ritual orgies.

Everything became rhythm and unexplored life to me. I became as furiously mad as a nigger. I no longer knew what I was doing. I cried, I sang, I howled, I rolled on the ground. I performed Zulu dances. Seized with a religious terror, I prostrated myself before a granite block which I had placed in the room. This block was alive in a chimerical sort of way, and full of riches, like a cornucopia. It rustled like a hive. It was a hollow, glowing shell. I plunged my hands into it as in an inexhaustible sex. I beat myself against the walls in order to split, to pierce through the visions which were coming up all around me. Thus, I bent the swords and the fencing foils and the rapiers, and I smashed the furniture with terrific blows. And when Rita asked for me—she still came occasionally, on horseback, not even getting down from her mount—I had a desire to rip her skirts to pieces.

ONCE, however, towards the end of the year, Rita, dressed in her long riding clothes, got down off her horse, and let me lead her to the salle d'armes. There she stretched out on the floor facing me, as of old. She was especially good to me that day; sweet and grave, she lent herself to my slightest caprice.

"Turn your head a little," I said to her. "There! Thanks. Don't move now, please. You are as beautiful as a stovepipe, polished and rounded upon yourself, and elbowed. Your body is like an egg by the side of the sea. You are as concentrated as a salt jewel and as transparent as rock crystal. You are a prodigious flowering, a motionless vortex. Abyss of light. You are like a sounding lead descending into incalculable depths. You are a blade of grass a thousand times enlarged."

I was terrified. I was afraid. I wanted to slash her. And then she arose. Nonchalantly putting on her gloves? Announcing her departure? She says she has come for the last time? Says she is called to Vienna, that she is going to spend the winter at Court, that she has already been invited to balls and fêtes, that the season promises to be very brilliant . . . I no longer listen to her. I cease to hear anything. I throw myself upon her. I bowl her over. I strangle her. She fights, strips my face with blows from her riding whip. But I am already upon her. She cannot even cry out. I have plunged my left fist into her mouth. With the other hand, I give her a terrible cut with a knife. I split open her abdomen. A wave of blood covers me. I rip out her intestines.

And here are the consequences: I am locked up in prison. Eighteen years old. That was in 1884. Shut up in the fort at Pressbourg. Ten years later, I was secretly transferred to Waldensee, with the insane. Nobody will have anything more to do with me. I have been mad for ten years.

André Gide (1869–1951)
Section of *Si le grain ne meurt*

Paris: Editions de la Nouvelle revue française, 1924
Translated in Florence, April 17, 1927
Manuscript
WEA 1994.250.1 (24)

Gide was a provocative literary figure in Paris from the turn of the century to World War II. Evans's excerpt from Gide's scandalous, confessional autobiography, *Si le grain ne meurt* (If it Die), is drawn from the first episodes of the book. Triggered by family photographs, Gide writes of his earliest memories—disparate images of childhood games, summer evening walks with his father, and early sexual explorations. In this section, one can imagine Evans's delight in the exquisite clarity of Gide's prose. Just as Gide savored the consequences of the kaleidoscope's visual dynamics—one small movement could change the entire picture—so Evans would linger over the subtleties of precisely editing and re-editing the content of his stories and photographs.

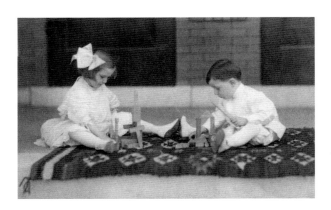

Unknown Photographer, [Jane and Walker Evans Playing Blocks], 1905–06, platinum print, 13.8 x 20.6 cm The Metropolitan Museum of Art, Purchase, The Horace W. Goldsmith Foundation Gift 1996.166.6

Another game I was mad about was that marvelous instrument called kaleidoscope: a kind of looking glass which, at the other extremity from the end into which you look, presents an ever-changing rosette made up of moveable pieces of colored glass held between two transparent sheets. The inside of the looking glass is lined with mirrors in which the phantasmagoria of the glass pieces is systematically multiplied, the slightest movement of the instrument changing the design. This threw me into indescribable delights. I still distinctly recall the color and form of the glass scenes: the largest piece was clear ruby; it was triangular in form; its weight led it first and over the rest which it upset. There was a very dark and almost round garnet; a blade-like emerald; a topaze of which I recall only the color; a sapphire, and three little golden brown left-overs. They were never all in sight at once; certain ones stayed completely hidden; others half out of sight at the far edges on the other side of the mirrors; the ruby alone, too important, never entirely disappeared.

My cousins, who shared my liking for this game but showed less patience in it, would shake the instrument each time, in order to see a complete change. I did not go about it that way: without taking my eyes from the scene, I turned the kaleidoscope slowly, slowly, admiring the gradual modification of the rosette. Sometimes the slightest movement of one of the little parts would have terrific consequences. I was as much interested as struck by it, and soon wanted to make the thing give up its secret. I unscrewed the end, took account of the glass pieces, and pulled these mirrors out of the case; then put them back; but with them only three or four pieces of glass. The result was rather sorry. The changes no longer surprised me; but how well the parts could be followed in their movement! How well the reasons for the pleasure could be understood!

Then I wanted to substitute the queerest objects for the glass pieces: a pen nib, a fly's wing; the head of a match, a blade of grass. It was opaque, no longer fairy-like at all, but, on account of the reflections in the mirrors, of a certain geometrical interest. … In short, I passed hours and days at this game. I believe the children of today don't know of it, and that is why I have spoken of it at such length.

[Self-portrait, Juan-les-Pins, France],
January 1927, WEA 1994.251.a

Essays in French 1926

In the summer and fall of 1926 Evans wrote short essays for the language courses in which he was enrolled. Although his instructors generally appreciated Evans's imaginative inventions, they chastised him to improve his grammar.

[Avis Ferne], ca. 1926, 10.3 x 5.8 cm
WEA 1994.261.34

"Chère Avis, Avis chère"

Written in Paris, June 1926
Typescript by Evans, hand-written comments by teacher and Evans
WEA 1994.250.2 (2)

For a homework assignment at the Collège de la Guild, Evans submitted a letter to his girlfriend back home, an artist's model named Avis Ferne. In it, he distinguishes himself from his fellow countrymen, whom he dismisses as "disgusting" expatriates, and laments the disappearance of the Paris of his dreams. As an exercise in self-invention, this essay reveals the young Evans as a precocious student of the Gallic stance.

Dear Avis, Avis dear:

Finally in Paris, it's incredible! I walk through the streets thinking about the illusions created by writers from the past. The Paris of Baudelaire, Verlaine, Huysmans and Rémy de Gourmont; the Paris, if you will, of the "Confessions of a Young Englishman" or of Oscar Wilde is no longer here. There still is a sense, but that's all.

But there's another Paris: the Paris of the Dôme (American), of the Rotonde (sickening), a Paris of Surrealism (?). Even our André Gide is old-fashioned here. I also find the city slightly, I think, rogue, you know? Everyone is posing; everywhere. Cocteau and Picasso, yes, really good! But there are others, not at all dead, not at all. For me, Corneille is dead, because he never lived … for me. But Barbey d'Aurevilly and de Villiers de l'Isle-Adam are my friends, they're really good friends; they're alive for me, they are part of my inner world. Oh, and there's Proust, Proust, Proust. A Paris where Proust is in the fashionable salons makes me cry. He is in fashion! Phew!

Cosmopolite Paris eats and eats and eats. But not at nine o'clock. You starve until noon, then you stuff yourself relentlessly. After that, you're carried out of the dining room and you spend the afternoon in a trance. The heavy and unhealthy hours go by. Read, write, think, work—all of that is impossible. You fall asleep, maybe you even dream (Hamlet!). At eight o'clock: you eat again. You need a taxi to leave the restaurant. If you go back to the hotel, you go to bed right away, if there's an elevator; if not, you sleep on the floor of the lobby. What would Bernard Shaw say about that? Maybe that's why he doesn't like Paris; you know that he doesn't speak French. He likes to say that it's impossible for him to learn.

It's the same with me. I speak terrible French and I don't write it any better. Believe me, you're rather thick here, when you don't speak the language. Oh, how crazy of me to have let the hours go by when I was taking classes in Boston!

But I'm drifting; it was my intention to write a nice sweet letter. They say that's why the French language exists. You know, we don't really have words to express strong feelings. I was going to look up some exotic love words in my new and wonderful dictionary. This would have been a masterpiece, you can bet. I would not have used a letter like that for my weekly essay …

Teacher's comment at top of manuscript:
Interesting. Written in a modern, very chaste and concise style, rather surprising. You should work seriously.

Teacher's comment at bottom:
Paris, like your favorite authors, can't be read right away; you have to earn the right to understand it, just like for the authors. Forget them a little and look at it with your own, it seems to me, very perceptive eyes.

Evans's note at bottom:
June 1926
Collège de la Guild
Corrected by Mme Berthier

Translated from the French by Charles Akin

"Le soir, je me sentais isolé …"

Paris, August 7, 1926
Typescript by Evans, hand-written comments by teacher and Evans
WEA 1994.250.2 (5)

Asked by professor Broche to write an essay on a nineteenth-century poet, Evans modeled this assignment on the prose poems of Baudelaire that he had been busy translating. Evans writes with characteristic inventiveness in the style of "The Double Room," caught between liberating dreams and the prison of coarse reality. A self-styled outcast isolated from the abhorrent optimism (what he describes as "the perverse health of America") and crass materialism of his homeland, Evans armors himself with the bitter spleen of his literary idol.

August 7, 1926

In the evening, I feel alone; you become introspective. We're too young. This youth bothers me a lot. Here is my diary, for example—a witness to my introspection and egoism. A long time ago, no. At the time of the Renaissance, you were introspective and you were a Cellini. Why, I wonder, is it that now the diaries and autobiographies are all subjective? You hear everywhere that it's the tempo of our times. I should be a little bit more unhealthy in order to be in step.

There was a lecture this morning. *Rara avis:* a professor who could hold my attention. For two hours! I can't remember what he said—something about the education system in France; it's not important what he said, it was so well expressed. Now I have to write an essay on the poet of the 19ᵗʰ century with the whys and all the reasons!!

Me who strongly maintains the theory that poetry cannot be translated and who doesn't think that I have learned enough French to be really capable of expressing the essence of his poetry … I can state that when I think of it, I think of Baudelaire, Verlaine and Rimbaud. But which? And what do I have to say about their work? I know all about each of these men's courageously daring lives. For me, I needed to know that men like these lived, although I had Whitman and Poe.

C'mon, you have to make a choice. Let's take Baudelaire, because you have in front of you a beautiful edition of *Fleurs du Mal*. Read a little bit. You know "Les Bijoux" well because you read it when you were eighteen at the New York Public Library when you learned that it was one of the censored poems. But not that. C'mon … no! I think only of B.'s ideas—*fleurs du mal*, spleen, the ideal, death, rebellion—I can understand why you turned to those images when you were troubled, caught up in the perverse health of America. Oh, yes, the smells, the corpses, the doomed women, all of that was your safe haven at that time. And you thought that the spirit of B. was formed like a bird builds a nest—bits of straw,

women's sorrows, earth, showers of black stars, rags, rotten wood, corrosive dreams, pieces of roses, the fumes of incense, music and the abomination of loneliness.

I think you liked B. because you read: if a fat woman is sometimes a charming caprice, a slender woman is a fountain of tenebrous voluptuousness. You always liked the slender girls better. But all of that is not French poetry of the 19th century; you can't write an essay about those things.

My professor will be delighted to read these lines that you found in a New York newspaper last year!

I would I were a decadent!
[...]

Teacher's comment at bottom:
A rather original piece of homework; and on the whole well written.
Read a lot in French to improve your writing. You write very well.

Evans's note at bottom:
Corrected by Broche

Translated from the French by Charles Akin

I would I were a decadent!
 I would I were perverse and hard!
I would I were an egocentric bard!

Fain would I chant of evil's lure,
 Of Satan as my childhood doll,
Fain would I write a book like "Fleurs Du Mal."

Pain's bliss and squalor's pungent lees,
 Joy's stench and virtue's vapid touch, -
Exotic stuff like that would please me much.

It seems that I am doomed to spout
 The usual effusive croon:
Correctly tender lines about the moon.

To Baudelaire I give my hand -
 He is the cat's catastrophe!
But, lacking him, you'll have to stand for me.

*Devoir original
aussi bien écrit dans
l'ensemble - Citz beaucoup le
français pour perfectionner votre expression
vous pouvez très bien écrire ___*

Corrigé par Broche

"A propos, chose plutôt intéressante"

Paris, August 14, 1926
Typescript by Evans, hand-written comments by teacher
WEA 1994.250.2 (6)

In this assignment, Evans travels far afield from the appointed topic of "Art for Art's Sake," to reveal his innermost feelings on a wide range of subjects. For the young Evans, the work of art is a sublimated expression of sexual desire not only for its creator, but for its audience (particularly the young female ones) as well; at first glance surprisingly outspoken, Evans's attitude here is actually a variant on the then-standard anti-Victorianism of the modern ethos. Before concluding his diatribe with the obligatory anti-elder rallying cry, however, Evans provides his perhaps most revealing comments, this time about his silently suffering classmates with their "broken souls." In this almost painfully candid homework assignment-as-confessional, Evans seems both to be trying to stand apart from youthful angst and to be describing it in himself at the same time. The teacher sprinkled the piece with question marks and grammatical corrections as well as a rather perplexed comment: "The expression is sometimes obscure. Aim at clarity." It seems that Evans's essay caused his teacher some alarm and that he may have talked to him about it—on a list of experiences during his stay in France and Italy in 1926–27, Evans included "Broche + my essay."

"By the way, something rather interesting: one of my professors assigned an essay for tomorrow about a discussion of our old friend *art for art's sake*. It's a question of Gautier versus Hugo. That's why we can't have dinner here tonight. I have to go home and begin writing."

We were in the country. The ordinary landscape was compensated by my wonderful companion. People around us left furiously. They were religiously out of place in daily life. I tried to stay on the subject, but she made me wander …

"But now, my friend, all that's finished. Do you want me to tell you what I think? It's that we now have the question of art as sexual expression."

"I know; yesterday I was reading the preface to *Mademoiselle de Maupin* and really, I was shocked (when I wasn't bored) by what seemed to me to be false in the thoughts of the great Théophile. I have, you know, a sentimental interest in this book, although it's a bit naïve to say it. But he didn't say a word about the role played in art by the sexual impulse. It's not only that some artists, directly or without doing it consciously, put sexual ideas and dreams in their work: it's the audience that uses art as a substitute … do you understand? Have you seen that the people who fill the museums and who buy books are usually starving women? I'm talking about the situation of the British and the Americans. Oh, the ugly and dried-up women, always from good families, living horrors that madly rush to lectures and to the Arts (with a majuscule)! You can read in their eyes the story of terrible nights. Yes: art for the sexual needs of well-bred women …"

"Very interesting, my friend, but you can't write like that on Gautier's theories."

"Don't interrupt me, please. I was talking just now about starved women, wasn't I? Yes, listen: in that course where I'm going to turn in the essay, most of the students are … are … everyday I sit in a room filled with broken souls, struck by some sorrow which—and that's the terrible thing—is not necessary. I feel that our fathers' generation is a stupid generation. Say what you want of young

intellectuals; you will never find one who will stay away from the banquet of life or who will add drops of poisoned bitterness to this already so sad world or who will show the world the spectacle of an empty life, without meaning. Let's bury our dead."

"Tell me, why so much fuss? No one hurt you, I hope? You could say that you are jealous of this suffering that you don't want. And I see the rich man's hatred of the poor man. Does nobody have the right to be starving?"

"Please excuse me."

She was angry and with reason, I must admit. I just had to invite her for dinner.

"And what's your essay on?"

"I can't be bothered, I won't write it."

Teacher's comment at top left:
The expression is sometimes obscure. Aim at clarity.

Je dis que la génération de vos pères est une
Jeunes
qui
restera hors de la banquet de la vie, qui mettra
les gouttes d'amertume empoisonnée dans ce monde
déjà assez triste, qui montra au monde le spectacle
d'une vie vide, sans signification. Nous enterrons
nos cadavres.

- Tiens, tiens, pourquoi cette agitation? Personne ne t'a fait mal, j'espère? On dirait que tu es jalouse de cette souffrance dont tu n'as pas la volonté. Et je vois la haine de l'homme riche pour l'homme pauvre. On n'a pas le droit, donc, d'être affamé?

- Je demande pardon.

Elle était faché - avec raison, je dois avouer. Il fallait que je l'invitasse pour dîner.

- Et ton thème?

- Je ne paux pas être ennuyé, je ne l'écrirai pas.

Translated from the French by Charles Akin

Fiction 1925–1932

Between September 1925 and February 1932 Evans wrote a dozen short stories. Collectively the writing reveals the genesis of Evans's artistic vision—introspective in tone, lapidary in technique, and infused by a narrative objectivity that also happens to provide an invaluable record of Evans's internal life. Evans mostly worked in solitude and seems to have shared his writing only with his periodic roommate, Hanns Skolle, a German painter and writer who served as a capable and supportive editor. Evans did submit his work for publication but, so far as is known, none of his essays ever appeared in print. Notwithstanding their commercial failure, the stories are smart and finely honed. Evans seems to have thought so too: he meticulously kept the many drafts of each story, preserving for posterity not just the finished work but also the arduous journey to it.

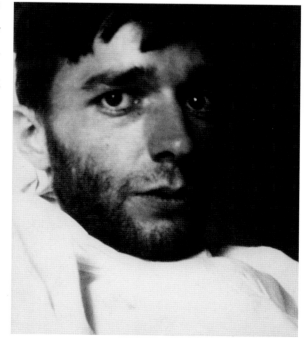

[Self-portrait in New York Hospital Bed], June 1928,
14.6 x 12.7 cm
The Metropolitan Museum of Art, Anonymous Gift 1997.233

STOMACH TROUBLE

Thats a thing I never - I dont smoke an I dont drink. I guess
Im pretty - I guess you wont find - - Ive got colitis. I guess you
never heard a that bafore. Ive had it every since I was a little
girl. Theres certain things I cant eat. I been sick, oh I been sick
with that colitis. I was in Europe, I was is Germany an I couldn eat
that heavy food. The food is ver-y heavy, you cant eat it if youre
used to good food like I am. I was taken sick an I couldn get food
I could eat so I packed up an I went to Brussels. I didn know I had
colitis, those Germans never heard of it bafore. I ate Brussels sprouts.
I was a sick woman. Paris is the best place in Europe to be sick in
so I packed up an I went to Paris as quick as I could go an I went
straight to the Hotel Lazaire. Its a byootaful hotel an they cut off
the telephone an I hadda ring for the porter to walk up fi flights
a stairs. I said Im sick - mauvais. I said you get me a docter anna
nurse juss as quick as you can - I ate a omlet, omlet is poison to
colitis. An he called up Docter Beauvier. If you ever need a docter
in Paris thats the man I wanna recommend. Hes been over to Amurica
six times an hes studied medicine in six differnt languages, German an
French an Italian an.... English an.......... hes been over to
Amurica. He said Missuz Mory, dont worry he said, Im fifty-six an
Ive had the same identical thing. He doesn look a day over thirty-
five, an he gave me a hypodermic that he musta put a little opium in.
He said youll have funny dreams. Ive had hypodermics an morphine
but that was the first hypodermic ever done me any good. Ive had
X-rays. But that was the first hypodermic....... I wanna tell you
I was a sick woman. Hed had it, an in six days he had me eatn things
I coulda never touched bafore. Its the way you cook food. I studied

```
chemistry when I was in school.  I had my appendix out in Rome......
..................     .......  ...   .
```

"Stomach Trouble"

Brooklyn, winter 1928–29
Typescript
WEA 1994.250.3 (8)

Evans wrote the first drafts of this comic monologue while employed in the Map Room of the New York Public Library in 1925, and continued revising it through early 1929. Using the trope of an overheard conversation, the author highlights the provincialism and vulgarity of an American woman abroad as she recounts the various gastrointestinal problems suffered while touring the great cities of Europe. An admirer of the misanthropic American editor and critic, H.L. Mencken, Evans attempts a similarly withering critique of the ugly American, whose function the caustic critic described as being solely "to amuse the world."[1] In his various draft revisions, Evans also reworked the stream-of-consciousness verse to give his protagonist's voice the cadence and slang of street talk, perhaps in response to E.E. Cummings's portrait poems of anonymous citydwellers using vernacular speech, which were published in a 1926 collection of poems Evans owned.[2] In its acid-tipped wit and sharp observation, this short piece is a remarkable blueprint for Evans's first photographs of street characters.

"A Love Story"

France and New York, September 1926–July 1928
Typescript
WEA 1994.250.3 (20)

Simultaneously personal and elliptical, this story of a failed relationship with a Scottish girl is probably loosely autobiographical. On a list of experiences during his stay in Europe Evans noted "L'Ecossaise" (The Scottish girl) and he either traveled with her to Brittany, or met her there in September 1926. Evans's use of a deadpan, pared-down style to describe youthful romantic turmoil seems to reflect at least a passing awareness of Ernest Hemingway's "Nick Adams" stories published in *In Our Time* (1925). What the young Evans adds to the formula is most revealing: a mordant streak embodied by the "mysterious wall" the couple muses upon and an unborn, ultimately miscarried, child that in earlier drafts is "discarded." While the protagonist's pronounced disdain for the Scottish girl's "socialistic" and "genuine" tendencies are somewhat tempered in revisions, Evans casts an interesting light (perhaps unwittingly or self-mockingly) on his attitudes towards both intellectual women and political commitment.

A LOVE STORY

I once took my meals at a boarding-house in a foreign country. That was one of the ways to learn the language. In this case it was a mistake, because everyone else came there for the same purpose.

Besides a Scotch girl there were at table: a Pole who was all right, and his wife; a Dane who had no flavor at all; an English boy for whom I was always embarrassed; three English girls with perfect table manners; the fat and vulgar lady of the place; her daughter-in-law. There was also an unborn child, carried by the daughter-in-law, and getting along swimmingly, I thought.

All of these people were unimportant to me and to themselves.

Often I sat next to the Scotch girl. It was clear from the start that she was courageous and big and "genuine" and a communist. Her English was very Scotch and not always correct. But for this misfortune she might have been perfectly charming. I pretended she was. This fraudulent wish-fulfillment damaged my summer.

Every noon and every evening we ate that terrible food. I thought about fried pork and the unborn child.

The Scotch girl came to my place and I showed her my mysterious wall. It was at the end of the garden, and in all that stone expanse there was only one small iron-barred window, high up. Some nights there was a light. At various times there were different noises, usually bells. It was a fine wall. On Sunday mornings a violin and a voice played and sang behind it. The girl said something about smashing

through to get at the human suffering. That was the first I
had heard of it. But she had to say that. I attempted to
smile inwardly and say to myself that we were different: I
liked the mystery and she liked the human suffering; and that
de gustibus, and so forth.

It was a madhouse, I think.

At the end of the summer the Scotch girl planned to go
to the coast for a week or so. I said I'd meet her there,
at a fishing village. The mayor of this village was a com-
munist, of course, and a hero too, for having lead the big
strike of the fishermen some years ago and got shot in the
eye by the government. The Scotch girl wrote to this mayor
and said she was a comrade and that she was coming with
another comrade and wanted cheap, clean rooms in the town
for that purpose. He wrote back: all right. I had to go first
somewhere else to see someone about something. Then at the
appointed date I got a place in a motor car with some nice
Canadian ladies who were traveling abroad. My hat saved me
from those ladies, except that they took a snapshot of me and
the driver because of it.

I got to the fishing village late at night. The next day
the famous mayor was out. The place was very good, with no
tourists nor resorters. I walked around and came upon the
market place. There was the Scotch girl with a basket. She
was buying staple commodities. I leaned against a post and she
saw me. She said she hadn't thought I would come.

A few miles above the village there was a good beach. We went there with food for the day. On the way we separated and then made no effort to come together again. I went on along the sand about a mile, without looking back. The situation was serious. I asked God some sharp questions. Nothing happened.

I sat down and thought that something ought to happen. I deserved a vision or a revelation because if I had seen something dubious in nature at that moment I should not have been at all surprised. An apparition would have appreciated me, too, because I should have treated it as an equal. I had sardine sandwiches and I should have offered one; I should have sat there calmly eating had the earth opened before me. I might have had a foresight of a thing that happened a little after this so that when it did happen I could pretend to be surprised. But instead of seeing something peculiar or foreseeing that thing that happened later, I just lay there and imagined things of different shapes and colors and thought about what they would do and what I would do.

*
* *

When I got back to the city I found the boarding-house deflated and subdued. Everybody looked thinner. The unborn child had been miscarried.

I haven't done any traveling since.

July 1928

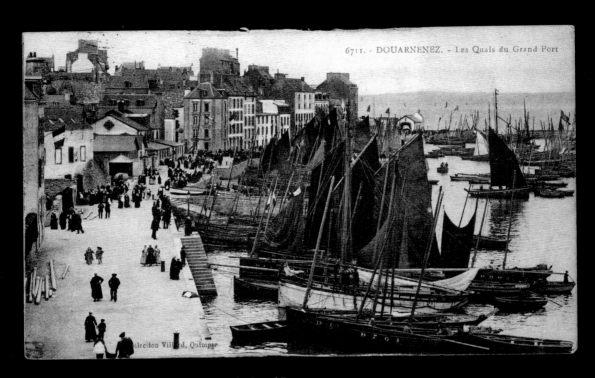

Picture Postcard of Douarnenez—Les Quais du Grand Port,
hand-written text by unidentified author "E.J.R,"
probably Scottish girl with whom Evans had visited Brittany,
September 14, 1926, WEA 1994.260.17 (17)

have just received your letter with enclosed 20 francs, which is the exact amount for your room. I naturally guessed there was something the matter with you, but hought it was rather a case of a 'mind diseased' than an 'estomac.' You certainly hould have told me more definitely. I could have done something, having gone hrough your experience.

I leave here on Thursday morning at 6 o'clock arriving in Paris about o'clock or 7.30 at Montparnasse I think. If you wish to see me, meet me then. shall look out for you. E.J.R.

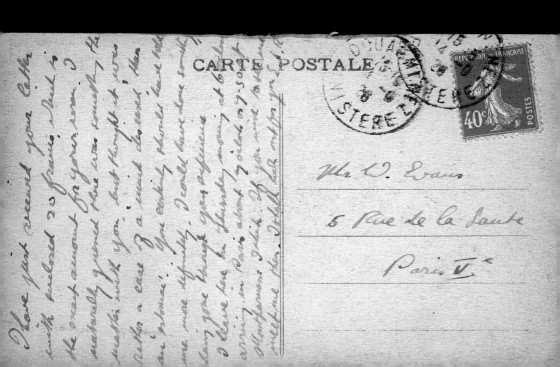

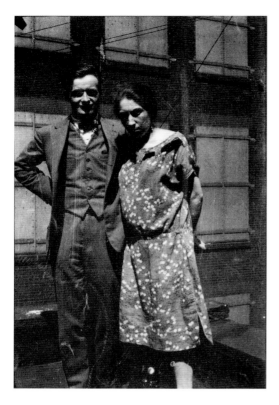

[Hanns and Elisabeth Skolle, New York City], 1928
WEA 1994.251.134

"Frederick and Marie"

1927
Typescript
WEA 1994.250.3 (22)

Originally titled "A Story in Which Something Happens," this piece is also based in the author's personal experience. Returning home from his year abroad in 1927, Evans found that his former roommate and close friend Hanns Skolle had married a Frenchwoman, Elisabeth Chavanon. In Evans's version of their marriage, the narrator coolly describes the newlyweds' relationship (their names changed in later drafts), the arrival of a newborn which the narrator contemptuously refers to as "the appalling red thing," and his good friend's transformation from bohemian to bourgeois. Evans's eye for the telling detail and clean prose style allow "Frederick and Marie" to transcend its purely autobiographical interest to achieve an astute, if harsh, evocation of domestic life and of his own ambivalence towards it.

FREDERICK AND MARIE

Frederick Vortz listened in the evening to the
piano playing of Marie Alliaume. They were legally
married; the piano they rented.

Frederick's wife was thirty, and so was the
piano. She was bien-pensante, the piano was upright,
though dilapidated.

Debussey, from the depths of the late Nineteenth
Century, composed the music of the evening - more
often than not.

Frederick was twenty-four; twenty when he found
me in the New York Society Library, covered with dust.
He had read Dostoïevsky at fourteen and had drunk with
people in Leipzig who were expressing themselves as
freely as they could and as wholly as they could. There
he received a lot of intellectual impressions: he made
himself sick with his own thoughts. He investigated
strange places and stranger moods. He made with his own
hands his Armour. In it he was very uncomfortable, with-
out it - he bled.

Marie married Frederick while I was in Paris. They
were in New York; I tried to figure it out for myself. I
found later that Marie had sat to, or posed for, Frederick,

who found he could not paint her type. She bacame self
indulgent: conceived a child. Marriage was discussed
and perpetrated. Frederick met me at the pier when I
landed.

Where he had dreamed, now he worried. He had
never mistaken his dreams for possibilities; now he
found the suspicion that both belonged to the free state
he had known before the funny thing happened to him.
In kicking from under him the prop of bourgeois
life, Frederick had lost the conviction of his own social
entity. Had I too not kicked.... but I had; I had kicked
as far as Paris and had left him with his guard down.

I was ill for a few days; then I rang the bell
of the thirteenth street studio. I saw her in the next
room. Some sort of presentation was made which we all
passed off apologetically. Our breeding came into play.
Together we dined, and made that evening as difficult as
possible. All spoke English.

* * *

The French bourgeoisie produces tenacious
women; their grip is on life itself. Marie carried her
child with a conviction which may have been preposterous.
It was probably only traditional. I learned how to keep
her off the exposition of her ideas on the bringing-up
of children, which was her mission and not mine. An
affection developed between the father and the mother
of this child who was going to be taught to love life.

We all went on living.

I was shocked to find myself an expectant god-
father.

* * *

Marie bore her child; she then offered us a
serenity which exasperated her husband and added to my
skepticism. The appalling red thing refused to recognize
us. We all went in for child xxxxxxxxx psychology. But
none of us could think of a good name.

I saw a mother lean on her man's shoulder before
a cradle. I saw a father cavort before his baby in a
frantic effort to impress his personality upon it. I was
surprised, and began to collect these experiences.

But back in Paris there was a great-grandmother
 Marie's
who appeared with increasing frequency in xxxxxxx conver-
sation. Frederick grew fonder of the piano. We kept it;
but Marie and the unnamed child are in the bosom of an
honorable French family — bien-pensante.

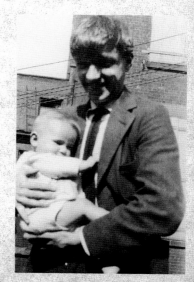

Hanns Skolle, [Walker Evans Holding
Anita Skolle, New York City], April 1928, 6 x 3.8 cm
WEA 1994.261.26

1927

"Brooms"

New York, February 1929
Typescript
WEA 1994.250.3 (45)

In the small but significant space that Evans's fiction occupies in his total career, "Brooms" is his finest achievement. Upon receiving this story, Hanns Skolle exclaimed: "Certainly the best thing extant. Congratulations!" Constructed as sturdily and functionally as the objects that give the story its name, it contains Evans's most sustained and unforced use of the experimental literary mode he had immersed himself in for five years. Ironically, this fullest flowering of his writerly talents comes in the service of a kind of unconscious literary farewell, in which he decided to "omit" all of the troubling confessional elements of his "inner life" once and for all. The impersonal, detached style he vows to undertake—to "suck the dust out of chaos"—becomes Evans's work with the camera, begun in earnest during the writing of this piece.

BROOMS

A change in policy. Journal won't do. Have decided
to continue but to omit dramas, crises, eruptions, explosions,
simmerings, boilings, and all manifestations of the chaos of my
inner life. Review before leavetaking: I am full of hate; have
wanderlust not only in Spring; am firmly intrenched in physical
life, and love it; am alone; have soul, to which I hereby bid
farewell.

When I took this place I simply couldn't buy a broom.
Couldn't buy anything. Sold, in fact, books, cameras; pawned
watch. There was no broom until I found one in the alley back
of the abandoned factory. It had a triangular shape. (I didn't
know anything about brooms.) I carried it home and swept bitterly.

I forgot to say that I shall eliminate dates. But I
shall go on writing. Every night I shall sit down and write
something that hasn't anything to do with my inner life.

Haaga the grocer has a sale of brooms, 39c.

I don't mind the cold. I don't mind anything. I am

detached. I walk along the street in the sunlight, with something
to do; something connected with my inner life, and therefore un-
mentionable. Divine power of thought. I forget what it is I
have to do. Left stranded on upper Bway in this condition.

I know I ought to buy a broom. There are times when
I actually could buy a broom, financially. But nothing has ever
come of it, morally.

Ena Douglas was born in Singapore. She now pays $12 a
month for a room on 14th ST. Has a long green dress and a long
cigarette holder which I sat on and broke in three (REPLACE), and
long vocabulary. All this means nothing to me.

Upon one of the main thoroughfares of the city, in a
commercial district, I found a cluster of super-brooms. Examined
them carefully. The handle of each was of ash, machine-turned ash,
I should say. This part of the implements had been dipped in
robbin's egg blue for youth and happiness. The sweeping part was
long and green, like Ena's vocabulary. The sweetsmelling reeds
were bound together with ochre twine. Groups of these brooms stood
swaying in the breeze, gladdening the hearts of the passers-by.
But I was sick of an old passion.

I am going to change my nouishment. I am weary of staple
commodities. I think I am in the frame of mind a man gets into
when he eats caviare for breakfast, as in Strindberg.

IMPERATIVE NEEDS:

 suspenders
 drawers
 collar pin
 bath slippers
 Crime and Punishment
 rubber cement

Words: the bottom of my life is a shadowy pattern of unreality, imposing enough in its own private way. I look into it coming out of deleria or even out of sleep on summer mornings before dawn, having set my will to go off at 4:30. Moi intime. My happy hunting-ground. My little core of humanity. Later it is shot through with cold sparks of intellect, or words to that effect.

Soon after I left the house, before I had even turned the corner, I saw a worn-out broom lying in the gutter. It is nothing, I said; it will pass. But I saw another, and yet another. All had that horrible, suggestive triangular shape. It was too much. Today, this dateless day, I walked into Macy's and bought a vacuum cleaner.

Now I shall suck the dust out of chaos.

Prose Poems and Lists 1926–1937

Throughout his life, Evans wrote intense little prose poems, lists, and sketches for proposed visual and literary projects. In these terse and often wickedly humorous pieces, Evans explored the minutiae of daily life and, with little or no narrative writing linking his field notes, forged these observations into a relatively novel form of literature and social commentary. Although E.E. Cummings's free-form technique and T.S. Eliot's detached, ironic point of view seem to have been influential on this aspect of Evans's writing, the works appear original in construction. Perhaps "blocked" as a writer, this inveterate collector of experiences discovered a unique way to record his preoccupations and unfulfilled desires.

[Lunchroom Window on the Bowery, New York City], 1933–34, WEA 1994.256.648

"disgust in the boat train"

1926–27
Manuscript list
WEA 1994.250.4 (2)

At first glance this two-column list seems to be a random sampling of Evans's daily experiences while on his year-long sojourn in France and Italy in 1926–27. With its repetitive refrains of "solitude" and careful observations of quotidian experiences interwoven with place names and addresses, this diaristic poem of Evans's mental and physical activities demonstrates a fine-tuned perception of the poetic resonance of ordinary but carefully selected and sequenced things, names, and places.

Digs
Disgust in the boat train.
The taxi horns of Paris.
In the Tuileries Gardens.
Wallace Backus
Shakespeare + Company
The bookshops
Gerbert + G.L.U.
Leonard Gaskell
Cocteau
Orphee
Mme Berthier
Correspondance with A.F.
Cannes
Mme. Berthier
1 Hubbard
2 Chez Mme. Bailly
Cannes
Solitude
5 Rue de la Santé
L'Ecossaise
Sikorski + a
Haine et honte
Broche + my essay
Levin, Paleologue
Douarnenez
Sikorski family troubles
Problem of JCE
Dinard
Tobacco
Solitude

Marcelle Isanbant
The Dôme
Léone
Urethritis, Dr. Motz
Campagne 1er; J. frightened
Sikorski's Saturdays
7 Rue Monge
Sorbonne
Solitude
Devoirs
Solitude
Zimmerer
Haine; Amertume
Villefranche
Vie aigné
Solitude
Juan les Pins
Solitude, soleil, santé
Mlle A.
Mme. A
Ms. Porter
Mlle A
mort
Traductions
Bateau Ivre
les Maury
Lucien Jacques
Si le grain ne meurt
Printemps Amour de la vie
Fin de la solitude
Bicyclette
Musique
Bicyclette
La folie à St. Jean
Hotel des Fleurs
Naples, Rome, Florence

Days
Disgust in the boat train.
The taxi horns of Paris.
In the Tuileries Gardens.
Wallace Backers
Shakespeare + Company
The bookshops
Herbert + G.L.4
Leonard Gaskell
Cocteau
Orphée
Mme Berthier
Correspondance with A.F.
Cannes
Mme Berthier
(Hubbard)
(Chez Mme Bailly)

Cannes
Solitude
5 Rue de la Santé
L'Ecossaise
Sekorski + à
Haine et honte
Broche + my essay
Deux Palissadens
Douarnenez
Sekorski family trouble
Problem of J.C.E
Dinard
Tobacco
Solitude

Marcelle Tsanbart
The Dôme
Skone
arthritis, Dr mots
campagny (er, J. frchtinet)
Sekorski's Saturdays
7 Rue Monge
Sorbonne
Solitude
5 Devoirs
Solitude
Zimmer
Haine; Amertume
Villefranche
vie aigüe
Solitude
Juan les Pins
Solitude, soleil, santé
Mlle G.
Mme A
Mme Ratos
Mlle A
mort
Traductions
Batran Eme
les maux
Lucien Jacques
Si le grain ne meurt
Printemps Amour de la vie,
Fin de la solitude
Bicyclette
musique
Bicyclette. Sa folie à St. Jean
Hotel des Fleurs
Naples, Rome, Florence

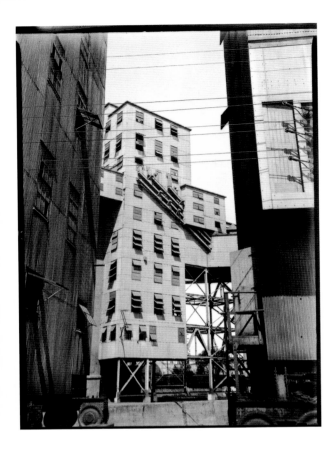

[Grain Elevator and Power Lines,
Montreal, Canada], August 1929
WEA 1994.255.120

"cross"

1929–1930
Manuscript poems
WEA 1994.250.4 (7)

Evans likely wrote these short poems between 1929 and 1930 when he shared an apartment in Brooklyn with the architect and photographer Paul Grotz. In August 1929 Evans and Grotz drove up the Hudson River and on to Canada where they each made a series of photographs of residential and industrial forms. We do not know if Evans composed the poems in response to the experience, or as post facto commentary on the photographs. He wrote the five poems on a single sheet of paper, each separated by a thin line; the effect is not unlike that of a page of proof prints one might make from photographic negatives.

cross
check
cube yourselves
black and white in the sun
it is nothing to me that you are a grain elevator
your wires carry another word
to my eye

———————————————

~~shadow~~
shade of a city
falling across the face of a one eyed monster
~~built by~~
hiding
~~for~~
~~awaiting~~
waiting
standing day after day
none sees this
threat

———————————————

cascades
dry
your water is the caress of my eye

———————————————

one part of a city
impaled
punctured cubes
full of stenographers desires banalities
not good enough for their shell

Text on verso:

To hell with the filthy punctured cubes of the city—architecturally speaking. Fourteen thousand two hundred *and* seventy three tragedies, 67284 mysteries, several obscure dramas with or without poetry there in the night.

"Contempt for:"

December 26, 1937
Typescript list by Walker Evans
WEA 1994.250.4 (21)

"Contempt or hatred for:"

December 26, 1937
Manuscript list by James Agee
WEA 1994.250.80 (9)

On December 26, 1937 Evans and his frequent collaborator, the American writer James Agee (1909–1955), simultaneously wrote a pair of angry lists. Evans typed his; Agee used pencil as he did for nearly everything he wrote. Although the mood is dark, the two artists' skills as modern stylists and social critics are at their apogee. At the time, Evans and Agee were inseparable. In the summer of 1936 they had collaborated on an article on three tenant farmers in Alabama which had been commissioned but then rejected by *Fortune* magazine. In the fall of 1937 they had received the publishing rights for the article back from the magazine, material which in 1941 would become *Let Us Now Praise Famous Men*. Yet in December 1937 the careers of the two men were dormant and they were dispirited about failures in their personal and professional lives. Evans had lost his job with the New Deal the previous spring; Agee's marriage was breaking up and he detested his banal journalistic assignments at *Fortune*. As these acerbic, Whitmanesque poems reveal, 1937 was a cruel year for Evans and Agee; nine months later, however, Evans would realize the publication and exhibition *American Photographs*, and Agee would complete the first draft of *Let Us Now Praise Famous Men*.

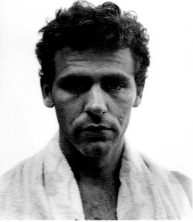

Left: Unknown Photographer, [Walker Evans, Washington, D.C.], 1935–37, 5.4 x 4.1 cm, The Metropolitan Museum of Art, Gift of Janice Levitt 1998.398.2
Right: [James Agee, Old Field Point, Long Island, New York], 1937, WEA 1994.254.a

contempt for:

men who try to fascinate women with their minds;

gourmets, liberals, cultivated women;

writers;

successful artists who use the left to buttress their standing;

the sex life of America;

limited editions, "atmosphere", Bennington College, politics;

men of my generation who became photographers during the
depression;

journalism, new dealers, readers of the New Yorker;

the corner of Madison Avenue and 56th Street;

the public;

Richard Wagner, radio announcers;

hobbies and hobbyists;

the soul of Josef von Sternberg;

the gay seventies', eighties, nineties, or hundreds;

art in America, the artist of America, the art lovers of
America, the art patrons of America, the art museums of
America, the art directors of America, the wivwes and
mistresses and paramours of the artists of America; the
etchings and the christmas cards and the woodcuts and the
paintings and the letters and the memoirs and the talk
and the beards or the cleanshaven faces of the artists
of America;

for college bred intellectual communists with private incomes;

for safe experimentation in living or in expression;

for merrie England;

for critics;

for passing away, passing on, going on, leaving us; instead of
dying;

for school spirit, Christmas spirit, gallant spirit, and
whatever is meant by The American Spirit;

Contempt or hatred for:

The Anglo Saxon tristesse
the Anglo Saxon optimism
Anglo Saxon men in relation to their women
Anglo Saxon women
English girls
female athletes
intellectual women
most women who say fuck, shit, fart, etc
most women who do not
all women who like dirty jokes
most women who do not
the liking for dirty jokes
limited editions, especially when signed
literary pornography
handsome volumes
slim volumes
zest
gusto
Rabelaisianism
book reviewers
sex education
literature
moving picture versions of Shakespeare, famous novels, and the lives of famous people
famous people
fame
English slang
the Americanisms of Englishmen
the Anglicisms of Americans
the Anglicisms of Englishmen
the professional American
"smart" women
"smart" people
those who live in the Barbizon Plaza

doctors
plays about doctors
The Group Theatre
Orson Welles's lighting
Archibald MacLeish's courage
whatever was responsible for my maternal grandmother, for Mrs. Saunders, for my mother,
for my stepfather, for my sister's trouble, for sexual pain, for the pain of sexual love.
every conception of motherhoods functions
those who bring forth, and up, children
those who despise them
those who say that things are slowly working themselves out towards the best
everything about William Shakespeare except William Shakespeare and his own writing
 ” — ” Christ except himself as I presume him, Dostoevsky, Blake, Kafka.
those who say, 'if only everyone would love one another'
the Van Gogh show at the Museum of Modern Art
the Surrealist show at same
Those who saw these shows
everything about Salvador Dali except a few of his paintings
Tchelitchev
Julien Levy
Film Groups, Guilds, Societés, etc.,
theatres which show the best foreign films
the word film
the word shot
the words cinema, swing, stuff, reactionary, swell, modest, contact, sexual intercourse, coitus,
classical historical objective, act of kind, conventional, unconventional, poet, art, cultivated,
mind, integrity, love, God, cozy, cunning, sweet, etc etc; such as, angle.
Walter Winchell
Bohemians
Lucius Beebe
pedantic wit
those who use no effort not to have their lives and thinking governed by their feelings
those who are not skeptical of their own premises
all self-confessed mystics and mahatmas who permit even one disciple
sensitive young men

unconsciousness of the self-betrayal of spoken language
peasant art in other than peasant contexts
old furniture
period interiors
the distortions which every falsehood imposes on every truth
most whose feelings get hurt
those who carry off unpleasant incidents with laughter
pipes and pipe smokers
the libraries of clergymen Alice in Wonderland
dog-lovers
the words pooch and mutt
the words prostie, bordello, etc.
the elaborate oaths of prep school boys
dictionaries of slang
the New Republic
Josef Stalin
Leon Trotsky
Karl Marx
Jane Austen
Paul Rotha
all books on movies
women through whose crotch you can see daylight when their knees are together
any creased droop under the breast
social crediters
American children who speak French
Every confusion of friendship and business
the face of Max Eastman
Walt Disney's human beings
most of the public of Disney and of Clair
publishers
journalists who like their jobs
 ” who say they don't but do

Like

fucking (including + chiefly comprised of all leadup and parody)
drinking
working when I do not hate it and every sensation following work
movies
music
city streets
auto driving
the cleaner degrees of weltschmerz and God
hatred
exhaustion
Buster Keaton
S J Perelman
beautiful bellies
Melanctha
Lenin
the life and conduct of Joyce
New Orleans
8 extensions of Swift, Grosz and Celine
the earth from the air
James Harold Flye

Criticism 1929–1969

Evans wrote literary criticism for forty years, from 1929 to 1969. After "Mad," his second published work was a review of John Langdon-Davies's book of essays, *Dancing Catalans*, in *Alhambra*, January 1930. While otherwise unremarkable, the essay included Evans's cryptic prophecy that: "The world is going to manufacture, buy, and sell goods violently, madly, and exclusively for some time to come."[3] His next review of six photography books, "The Reappearance of Photography," cut closer to the bone. Published in 1931 and probably commissioned by Lincoln Kirstein for his influential journal *Hound & Horn*, the essay provides a virtual outline of Evans's aesthetic program for his own career in photography.

In addition to contributing texts for his own new and then later reissued publications (*American Photographs*, *Let Us Now Praise Famous Men*, and *Many Are Called*), in the following years Evans reviewed some twenty books and films, as well as the work of Robert Frank, James Agee, Lee Friedlander, and other artists and writers. His last essay was a long chapter on photography in Louis Kronenberger's anthology, *Quality: Its Image in the Arts* (New York: Atheneum, 1969).

Ben Schultz (American, 1919–1967),
[Walker Evans at *Fortune* Magazine Offices,
New York City], 1950s, 19.5 x 17.4 cm
WEA 1994.261.72

"The Reappearance of Photography"

Book review
Published in *Hound & Horn*, #5 (October–December 1931)

Under the guise of a roundup of recently published photography books, in this article Evans constructed a history for the medium in defiance of the two most popular currents of photographic art: the painterly practice of Pictorialists, and the glossy commercial pictures that aped "New Vision" experimentation. Instead, the author proposed a historically-inflected photography true to its own inherent qualities of description and capable of an "editing of society." A typically oblique, indirect statement of intent, Evans's essay is a virtual manifesto of the documentary mode and a classic in the literature on photography.

The Reappearance of Photography

The real significance of photography was submerged soon after its discovery. The event was simply the linking of an already extant camera with development and fixation of image. Such a stroke of practical invention was an indirect hit which in application was bound to become tied up in the peculiar dishonesty of vision of its period. The latter half of the nineteenth century offers that fantastic figure, the art photographer, really an unsuccessful painter with a bag of mysterious tricks. He is by no means a dead tradition even now, still gathered into clubs to exhibit pictures of misty October lanes, snow scenes, reflets dans l'eau, young girls with crystal balls. In these groups arises the loud and very suspicious protest about photography being an art. So there is in one of the anthologies under review a photo of a corpse in a pool of blood *because you like nice things*.

Suddenly there is a difference between a quaint evocation of the past and an open window looking straight down a stack of decades. The element of time entering into photography provides a departure for as much speculation as an observer cares to make. Actual experiments in time, actual experiments in space exactly suit a post-war state of mind. The camera doing both, as well as reflect-

Eugène Atget (French, 1857–1927), *Courtyard, 12 rue Domat*, plate 1 from *Atget, Photographe de Paris* (New York: E. Weyhe, 1930)

80

ing swift chance, disarray, wonder, and experiment, it is not surprising that photography has come to a valid flowering—the third period of its history.

Certain men of the past century have been renoticed who stood away from this confusion. Eugène Atget worked right through a period of utter decadence in photography. He was simply isolated, and his story is a little difficult to understand. Apparently he was oblivious to everything but the necessity of photographing Paris and its environs; but just what vision he carried in him of the monument he was leaving is not clear. It is possible to read into his photographs so many things he may never have formulated to himself. In some of his work he even places himself in a position to be pounced upon by the most orthodox of surréalistes. His general note is lyrical understanding of the street, trained observation of it, special feeling for patina, eye for revealing detail, over all of which is thrown a poetry which is not "the poetry of the street" or "the poetry of Paris," but the projection of Atget's person. The published reproductions are extremely disappointing. They and the typography and the binding make the book look like a pirated edition of some other publication.

America is really the natural home of photography if photography is thought of without operators (sic). Except that Edward Steichen has made up a book that happens to stand on the present shelf, the American problem is almost too sad to restate—and too trite. Steichen is photography off its track in our own reiterated way of technical impressiveness and spiritual non-existence. In paraphrase, his general note is money, understanding of advertising values, special feeling for parvenu elegance, slick technique, over all of which is thrown a hardness and superficiality that is the hardness and superficiality of America's latter day, and has nothing to do with any person. The publication of this work carries an inverted interest as reflection of the Chrysler period.

Without money, post-war Germany experimented with photography heavily and thoroughly. There was an efficient destruction of romantic art-photography in

Edward Steichen (American, born Luxembourg, 1879–1973),
Matches and Match Boxes, *A design for Stehli Silks*,
from Carl Sandburg, *Steichen the Photographer* (New York:
Harcourt, Brace and Company, 1929)

a flood of new things which has since lost its force. But the medium was extended and insisted upon, even though no German master appeared. The German photo renascence is a publishing venture with political undertones. Renger-Patzsch's hundred photos make a book exciting to run through in a shop and disappointing to take home. His is a photo method, but turns out to be precisely the method that makes it said "painting is no longer necessary, the world can be photographed." It is a roundabout return to the middle period of photography.

Photo-eye is a nervous and important book. Its editors call the world not only beautiful but exciting, cruel, and weird. In intention social and didactic, this is an anthology of the "new" photography; yet its editors knew where to look for their material, and print examples of the news photo, aerial photography, microphotography, astronomical photography, photomontage and the photogram, multiple exposure and the negative print. The pictures are introduced by an essay which must be quoted (leaving its extraordinary English translation as it is in the book):

> *the importance to the history of mankind of development of instruments such as the camera, lies in obtaining increasingly complex results, while the handling of the*

apparatus becomes more and more simple. to maintain that "short cuts" by relieving him of all effort, lead but to man's greater dulness and laziness, is romanticism in the minor key. the field of mental struggle is but changed to another place. ... is it but necessary to master the implements of photography to become a good photographer? by no means: as in other fields of expression personality is required. the peculiar human valuation of form at the time is expressed in the photo just as it is in graphic art. ... it often occurs that photographs taken by the one will always appear uninteresting, though he be skilled in technique, while photoes by the other, who considers himself but an amateur and whose work is not technically perfect, yet invariabley are of forcible effect. ... some misinstructed people still raise the question

Albert Renger-Patzsch (German, 1897–1966), *Mountain Forest in Winter*, plate 45 from *Die Welt ist schön* (The World is Beautiful) (Munich: Kurt Wolff Verlag, 1928)

whether ... to produce a photo full of expression and finished to the very corners can be an impelling inner necessity. what we mean is the question whether we are ... concerned here with art. commonplace men and "connoisseurs", both of whom generally are misforms of existence, still often meet in refusing to the most finished of photographs the quality mark of "art." either there is here but the semblance of a problem, since the definition of art is wholly time-bound, arbitrary and ungreat, or human sight is totally deformed and susceptible only to one kind of beauty even opposite nature. if however we understand art as an end in itself, called forth by man and filled with "expression", good photographs are included.

83

Photographie is the French equivalent to *Photo-eye* with the added intention of giving a history of photography. It is without tendency but has lost consistency by a de luxe process of reproduction. An essay on *photographie vision du monde* could be a good deal briefer than the one which prefaces this collection. But it is valuable, in its French-intellectual way, a respectable statement of the functions and possibilities of photography. The reproductions do little to illustrate this essay.

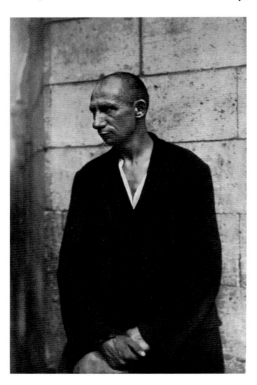

August Sander (German, 1876–1964) *Arbeitslos* (Unemployed Man), plate 60 from *Antlitz der Zeit* (Face of the Time) (Munich: Transmare and Kurt Wolff Verlag, 1929)

Finally the photo document is directed into a volume, again in Germany. *Antlitz der Zeit* is more than a book of "type studies"; a case of the camera looking in the right direction among people. This is one of the futures of photography foretold by Atget. It is a photographic editing of society, a clinical process; even enough of a cultural necessity to make one wonder why other so-called advanced countries of the world have not also been examined and recorded.

"I am applying for a Fellowship ..."

Essay written with Robert Frank to submit as the latter's
application to the John Simon Guggenheim Memorial Foundation, 1954
WEA 1994.250.5 (12)

"Robert Frank"

Commentary
U.S. Camera Annual, 1958
WEA 1994.250.52 (67)

From the mid-1950s to the 1970s, Evans served as an advocate for what he considered to be the best of the next generation of photographers—a select group that included Helen Levitt, Robert Frank, Lee Friedlander, and Diane Arbus. Evans directed magazine assignments to these artists and encouraged philanthropic organizations to grant them fellowships. The strong aesthetic and personal ties that bind these artists and Evans is a salient feature of post-war American photography.

In October 1954 Frank applied to the Guggenheim Foundation for a fellowship to photograph America—a project that would in 1958–59 become *The Americans*. His list of references was impressive and included Alexey Brodovitch, art director at *Harper's Bazaar*; Alexander Liberman, art director at *Vogue*, Meyer Schapiro, professor of art history at Columbia University, and Edward Steichen, curator of photographs at The Museum of Modern Art. Evans too was one of Frank's referees but he also deftly rewrote the single page typed description of the project proposal which Frank gave to his mentor. The Walker Evans Archive contains both Frank's provisional essay with Evans's annotations, and a copy of Frank's final application essay as rewritten by Evans. The final text is not pure Evans for it hangs on Frank's original scaffolding; however, many elements, such as the role of the photographer as archivist, classifying and cataloguing his photographs in the field, did not

appear in Frank's first draft. Evans loaned his concept of the role of the photographer to Frank like a suit of new clothes to make a good impression on the foundation judges. As a Guggenheim fellow himself, Evans was a member of the foundation's advisory committee, and so doubled his advocacy of Frank by authoring his own note of support. Not surprisingly, Frank received a fellowship for 1955–56; three years later *U.S. Camera Annual* published thirty-three of the photographs from the Guggenheim project with a commentary by Evans.

Robert Frank (American,
born Switzerland, 1924)
U.S. 285, New Mexico, 1956,
34.3 x 25 cm
The Metropolitan Museum of Art, Purchase,
The Horace W. Goldsmith Foundation and
Barbara and Eugene Schwartz Gifts 1995.162

ROBERT FRANK

I am applying for a Fellowship with a very simple inten-
tion: I wish to continue, develop, and widen the kind
of work I already do, and have been doing for some ten
years, and apply it to the American nation in general.
I am submitting work that will be seen to be documen-
tation--most broadly speaking. Work of this kind is,
I believe, to be found carrying its own visual impact
without much word explanation. The project I have in
mind is one that will shape itself as it proceeds, and
is essentially elastic. The material is there; the
practice will be in the photographer's hand, the vision
in his mind. One says this in some embarrassment but
one cannot do less than claim vision if one is to ask
for consideration.

"The photographing of America" is a large order--read
at all literally, the phrase would be an absurdity.
What I have in mind, then, is observation and record of
what one naturalized American finds to see in the United
States that signifies the kind of civilization born here
and spreading elsewhere. Incidentally, it is fair to
assume that when an observant American travels abroad

his eye will see freshly; and that the reverse may be true
when a European eye looks at the United States. I speak
of the things that are there, anywhere and everywhere--
easily found, not easily selected and interpreted. A
small catalog comes to the mind's eye: a town at night,
a parking lot, a supermarket, a highway, the man who owns
three cars and the man who owns none, the farmer and his
children, a new house and a warped clapboard house, the
dictation of taste, the dream of grandeur, advertising,
neon lights, the faces of the leaders and the faces of
the followers, gas tanks and postoffices and backyards...

The uses of my project would be sociological, historical
and aesthetic. My total production will be voluminous,
as is usually the case when the photographer works with
miniature film. I intend to classify and annotate my
work on the spot, as I proceed. Ultimately the file I
shall make should be deposited in a collection such as
the one in the Library of Congress. A more immediate use
I have in mind is both book and magazine publication.
Two European editors who know my work have agreed that
they will publish an American project of mine: 1)M. Delpire
of "NEUF", Paris, for book form. 2) Mr. Kubler of "DU" for
an entire issue of his magazine.

ROBERT FRANK

By WALKER EVANS

Rollie McKenna

ASSUREDLY the gods who sent Robert Frank, so heavily armed, across the United States did so with a certain smile.

Photographers are often surprised at some of the images they find on their films. But is it an accident that Frank snapped just as those politicians in high silk hats were exuding the utmost fatuity that even a small office-seeker can exhibit. Such strikes are not purely fortuitous. They happen consistently for expert practitioners. Still, there remains something mysterious about their occurrence, for which an analytical onlooker can merely manufacture some such nonsensical phrase as "the artist's crucial choice of action."

But these examples are not the essence of Frank's vision, which is more positive, large, and basically generous. The simple picture of a highway is an instance of Frank's style, which is one of the few clear cut signatures possessed by any of the younger photographers. In this picture, instantly you find the continent. The whole page is haunted with American scale and space, which the mind fills quite automatically—though possibly with memories of negation or violence or of exhaustion with thoughts of bad cooking, extremes of heat and cold, law enforcement, and the chance to work hard in a filling station.

That Frank has responded to America with many tears, some hope, and his own brand of fascination, you can see in looking over the rest of his pictures of people, of roadside landscapes and urban cauldrons and of semi-divine, semi-satanic children. He shows high irony towards a nation that generally speaking has it not; adult detachment towards the more-or-less juvenile section of the population that came into his view. This bracing, almost stinging manner is seldom seen in a sustained collection of photographs. It is a far cry from all the woolly, successful "photo-sentiments" about human familyhood; from the mindless pictorial salestalk around fashionable, guilty and therefore bogus heartfeeling.

Irony and detachment: these are part of the equipment of the critic. Robert Frank, though far, far removed from the arid pretensions of the average sociologist, can say much to the social critic who has not waylaid his imagination among his footnotes and references. Now the United States, be it said, will welcome criticism, and use it. At its worst moments, the U.S.A. today may seem to think that it is literally illuminated by the wide smile of one man, and saved for something-or-other by energy and money alone. But worse moments are the province and the mainstay of the daily newspaper.

For the thousandth time, it must be said that pictures speak for themselves, wordlessly, visually—or they fail. But if those pictures chose to speak, they might well use the words George Santayana once wrote in a small preface about the United States:

> " . . . the critic and artist too have their rights, . . .
> Moreover, I suspect that my feelings are secretly shared
> by many people in America, natives and foreigners, who
> may not have the courage or the occasion to express them
> frankly . . . In the classical and romantic tradition of
> Europe, love, of which there was very little, was supposed
> to be kindled by beauty, of which there was a great deal;
> perhaps moral chemistry may be able to reverse this oper-
> ation, and in the future and in America it may breed
> beauty out of love."

"James Agee in 1936"

Foreword to 2nd edition of *Let Us Now Praise Famous Men*, 1960

In September 1960, Houghton Mifflin published a second, enlarged edition of *Let Us Now Praise Famous Men*, Agee's and Evans's study of three tenant farmer families in Hale County, Alabama. The 1941 publication had been a commercial failure and sold less than 200 copies before being remaindered. By 1960, however, its reputation had grown "by word of mouth, by discovery, and by collector's item"[4] until the book achieved cult status as a Depression-era masterpiece.

Evans worked on the new edition for two years, expanding the picture section from thirty-one to sixty-two photographs, and writing the poignant foreword "James Agee in 1936." The Walker Evans Archive contains an early draft of the book's foreword titled "The Masked Moralist." The following passage from it, more subjective and passionate than the published recollection, presents a variant picture of Evans's best friend and most influential collaborator:

"We met by arrangement in Birmingham. He was wildly excited, and physically as energetic as a jumping, vociferating six-year-old boy. He whistled runs of Beethoven, ate double steaks, and drove the rented Chevrolet sedan demonically. He was also conspiratorial. Not politically, though—he scorned the New Deal liberals, the Socialists, and the Communists alike; condemned Quakers, trade unionists, and all the rest. I felt that Agee covertly knew who he was, as artist, moralist, and poet. The second of these was the least defined, of course, and the most masked. But after all, there was a pervasive moral challenge and stimulus in the air of that time, the depression. It gave edge and heft and bite to whatever a man like Agee did. This it did automatically, in a way that is emphatically not the case now."[5]

James Agee in 1936

At the time, Agee was a youthful-looking twenty-seven. I think he felt he was elaborately masked, but what you saw right away—alas for conspiracy—was a faint rubbing of Harvard and Exeter, a hint of family gentility, and a trace of romantic idealism. He could be taken for a likable American young man, an above-average product of the Great Democracy from any part of the country. He didn't look much like a poet, an intellectual, an artist, or a Christian, each of which he was. Nor was there outward sign of his paralyzing, self-lacerating anger. His voice was pronouncedly quiet and low-pitched, though not of "cultivated" tone. It gave the impression of diffidence, but never of weakness. His accent was more or less unplaceable and it was somewhat variable. For instance, in Alabama it veered towards country-southern, and I may say he got away with this to the farm families and to himself.

His clothes were deliberately cheap, not only because he was poor but because he wanted to be able to forget them. He would work a suit into fitting him perfectly by the simple method of not taking it off much. In due time the cloth would mold itself to his frame. Cleaning and pressing would have undone this beautiful process. I exaggerate, but it did seem sometimes that wind, rain, work, and mockery were his tailors. On another score, he felt that wearing good, expensive clothes involved him in some sort of claim to superiority of the social kind. Here he occasionally confused his purpose, and fell over into a knowingly comical inverted dandyism. He got more delight out of factory-seconds sneakers and a sleazy cap than a straight dandy does from waxed calf Peal shoes and a brushed Lock & Co. bowler.

Physically Agee was quite powerful, in the deceptive way of uninsistent large men. In movement he was rather graceless. His hands were large, long, bony, light and uncared for. His gestures were one of the memorable things about him. He

seemed to model, fight, and stroke his phrases as he talked. The talk, in the end, was his great distinguishing feature. He talked his prose, Agee prose. It was hardly a twentieth-century style; it had Elizabethan colors. Yet it had extraordinarily knowledgeable contemporary content. It rolled just as it reads; but he made it sound natural—something just there in the air like any other part of the world. How he did this no one knows. You would have blinked, gaped, and very likely run from this same talk delivered without his mysterious ability. It wasn't a matter of show, and it wasn't necessarily bottle-inspired. Sheer energy of imagination was what lay behind it. This he matched with physical energy. Many a man or woman has fallen exhausted to sleep at four in the morning bang in the middle of a remarkable Agee performance, and later learned that the man had continued it somewhere else until six. Like many born writers who are floating in the illusory amplitude of their youth, Agee did a great deal of writing in the air. Often you had the impulse to gag him and tie a pen to his hand. That wasn't necessary; he was an exception among talking writers. He wrote—devotedly and incessantly.

Night was his time. In Alabama he worked I don't know how late. Some parts of *Let Us Now Praise Famous Men* read as though they were written on the spot at night. Later, in a small house in Frenchtown, New Jersey, the work, I think, was largely night-written. Literally the result shows this; some of the sections read best at night, far in the night. The first passage of *A Country Letter*, is particularly night-permeated.

Agee worked in what looked like a rush and a rage. In Alabama he was possessed with the business, jamming it all into the days and the nights. He must not have slept. He was driven to see all he could of the families' day, starting, of course, at dawn. In one way, conditions there were ideal. He could live inside the subject, with no distractions. Back-country poor life wasn't really far from him, actually. He had some of it in his blood, through relatives in Tennessee. Anyway, he was in flight from New York magazine editorial offices, from Greenwich Village social-

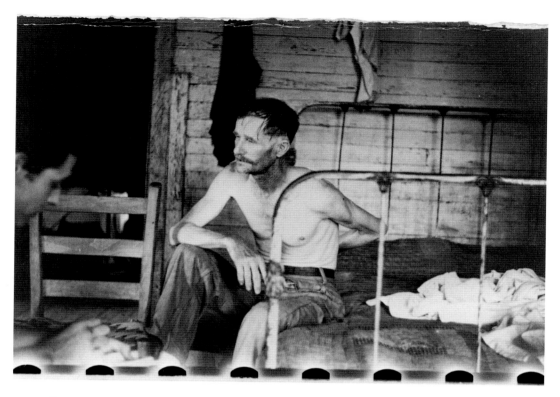

[James Agee (at left) Interviewing Bud Fields in His Bedroom, Hale County, Alabama], August 1936
Photography Collection, Harry Ransom Humanities Research Center, The University of Texas at Austin 968:004:024

intellectual evenings, and especially from the whole world of high-minded, well-bred, money-hued culture, whether authoritarian or libertarian. In Alabama he sweated and scratched with submerged glee. The families understood what he was down there to do. He'd explained it, in such a way that they were interested in *his* work. He wasn't playing. That is why in the end he left out certain completed passages that were entertaining, in an acid way. One of these was a long, gradually hilarious aside on the subject of hens. It was a virtuoso piece heightened with allegory and bemused with the pathetic fallacy.

He won almost everybody in those families—perhaps too much—even though some of the individuals were hardbitten, sore, and shrewd. Probably it was

his diffidence that took him into them. That non-assurance was, I think, a hostage to his very Anglican childhood training. His Christianity—if an outsider may try to speak of it—was a punctured and residual remnant, but it was still a naked, root emotion. It was an ex-Church, or non-Church matter, and it was hardly in evidence. All you saw of it was an ingrained courtesy, an uncourtly courtesy that emanated from him towards everyone, perhaps excepting the smugly rich, the pretentiously genteel, and the police. After a while, in a round-about way, you discovered that, to him, human beings were at least possibly immortal and literally sacred souls.

The days with the families came abruptly to an end. Their real content and meaning has all been shown. The writing they induced is, among other things, the reflection of one resolute, private rebellion. Agee's rebellion was unquenchable, self-damaging, deeply principled, infinitely costly, and ultimately priceless.

New York, 1960

"The Little Screens. A photographic essay by Lee Friedlander with a comment by Walker Evans"

Harper's Bazaar, February 1963, pp. 126–129
WEA 1994.250.52 (81–97)

Walker Evans had no children but was an important mentor to three of the greatest photographers of the postwar era: Robert Frank, Lee Friedlander, and Diane Arbus. Each made pictures describing the melancholy, isolation, and anxiety underlying the surface contentment of Eisenhower's America, often using the strategies of wit and irony that Evans had pioneered three decades before. In this little-known piece, Evans discussed Friedlander's photographs of motel room interiors, which he saw as a commentary on the vapidity of contemporary culture.

THE LITTLE SCREENS

A photographic essay by Lee Friedlander with a comment by Walker Evans

pictures on these pages are in effect deft, witty, spanking little [a]s of hate. They are the work of Lee Friedlander, one of the accomplished and sharp-minded of the younger American [photo]graphers.

[It] just so happens that the wan reflected light from home tele[visison] boxes casts an unearthly pall over the quotidian objects and accouterments we all live with. This electronic pallor etiolates our bed boards and pincushions, our mute scratch pads and our inglorious pillboxes. It is a half-light we never notice, as though we were dumb struck by those very luminous screens we profess to disdain. That disdain is not much mitigated by Friedlander's selective potshots. What *are* these faces (*Continued on the following page*)

at moon out from the screen? Taken out of context as they are here, that baby might be selling skin rash, the careful, good-looking men might be categorically unselling marriage and the home and al daintiness.

Here, then, from an expert hand, is a pictorial account of what screen light does to rooms and to the things in them. The man denizens of the rooms are purposely left out. In this at-mosphere of eclipse, the sense of citizen presence is actually increased.

For the thousandth time, let it be said that pictures which are really doing their work don't need words. Friedlander's stinging and toughly amusing, bitterly funny observations want no line captions, and in this instance they had better be called just One, Two, Three, Five, and so on.
———*Walker Evans*

Selections from "Photography"

Chapter by Walker Evans in Louis Kronenberger (ed.),
Quality: Its Image in the Arts (New York: Atheneum, 1969)

Quality: Its Image in the Arts is composed of seventeen chapters by critics and artists on the various arts such as Virgil Thomson on music, Elizabeth Hardwick on literature, and Harold Rosenberg on the idea of the avant-garde. The book was edited by Louis Kronenberger, *Time* magazine's theater critic from 1938 to 1961 and Evans's colleague at the magazine in the 1940s. Kronenberger asked Evans (then a professor at Yale University) to write the section on photography. Evans worked very hard on his text for this book and the Walker Evans Archive contains over 200 folders of manuscript material related to it, mainly drafts for the introductory essay and the individual entries.[6] The result was a general essay on his set of aesthetic criteria for the medium, entitled in its original drafts "The Seeing-Eye Men," followed by individual commentaries on nineteen photographs. In his introductory essay, Evans discusses the four basic tenets of "straight photography": "1) absolute fidelity to the medium itself ... 2) complete realization of natural, uncontrived lighting; 3) rightness of in-camera view-finding, or framing ... 4) general but unobtru-

sive technical mastery." While these tenets were pioneered in the 1930s, in the context of late 1960s cultural production, they represent a more conservative, institutional brand of modernist practice. It had obvious parallels to the formalism sponsored by Clement Greenberg who often praised Evans's "literary" mode of picturemaking during the 1950s and 1960s.[7]

While Evans's stringent prescriptions for the medium seem rather dogmatic and doctrinaire from today's vantage point, his commentaries on the individual photographs that follow are fresh with insight. He discussed photographs by Diane Arbus, Robert Frank, Erich Salomon, Paul Strand, Wright Morris, Edward Steichen, John Szarkowski, Bill Brandt, Harry Callahan, Henri Cartier-Bresson, Lee Friedlander, Nadar, W. Eugene Smith, Julia Margaret Cameron, Virginia Hubbard, Brassaï, Helen Levitt, Alfred Stieglitz, Walker Evans (listed anonymously), Marie Cosindas, and NASA. In the following selection of three pieces of this essay, the reader can appreciate what Evans's students must have enjoyed in their studies with the artist at Yale University during the 1960s.

Diane Arbus (American, 1923–1971)
Young Boy in a Pro-War Parade,
from *Quality: Its Image in the Arts*
(New York: Atheneum, 1969), p. 173

Diane Arbus

The subject on [this photograph] was discovered in a parade, in 1967, by Diane Arbus. This artist is daring, extremely gifted, and a born huntress. There may be something naïve about her work if there is anything naïve about the devil.

Arbus's style is all in her subject matter. Her camera technique simply stops at a kind of automatic, seemingly effortless competence. That doesn't matter: we are satisfied to have her make her own photography speak clearly. Her distinction is in her eye, which is often an eye for the grotesque and gamey; an eye cultivated just for this—to show you fear in a handful of dust.

This picture is a quick, brilliant comment; aside; in passing. Arbus's work as a whole is not propaganda. There is more of wonder than of politico-social conviction in her gaze. In any event, be it said (if in persiflage) that art ought not to be propaganda, which is useless; it ought to have purpose and a function.

Paul Strand

Camera Work, Alfred Stieglitz's simple but luxurious magazine of fine photography, published this print by Paul Strand—full page, of course, and in exquisite engraving set in wide white margins. The effect was breathtaking for anyone interested in serious photography; or in pictures, for that matter. Seeing it was a strong enough experience to energize on the spot any young camera artist with bold aesthetic ambitions. There is no question that Stieglitz's taste and brilliant showmanship made the Strand photograph fairly burn the eye, on this occasion. But Paul Strand made the original, and it is one of the lasting glories of the medium. It reverberates.

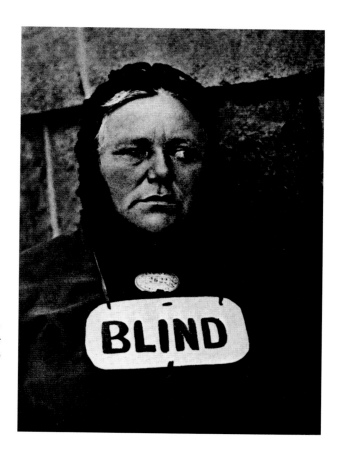

Paul Strand (American, 1890–1976) *Blind Woman,*
from *Quality: Its Image in the Arts*
(New York: Atheneum, 1969), p. 179

Alfred Stieglitz

It would be fitting to write of Stieglitz in the form of a rather tempered obituary:

Alfred Stieglitz must be called photographer incomparable. A good many serious photographers of the present and the future may never know how indebted they are to him. He was undoubtedly the most insistently "artistic" practitioner

Alfred Stieglitz (American, 1864–1946) *A Snapshot: Paris, 1911*, from *Quality: Its Image is the Arts* (New York: Atheneum, 1969), p. 207

of all time; with the adverse effect that it was he who forced "art" into quotation marks and into unwanted earnestness. On the other hand, Stieglitz's overstated, self-conscious aestheticism engendered a healthy reaction. We got a school of anti-art photography out of his protestations.

Yet Stieglitz produced some marvelous photography that was quite free of artiness, particularly in his early period. The print here reproduced is called simply *A Snapshot: Paris, 1911*. This seemingly spontaneous little picture is rather pictorial, to be sure, but it is neither forced nor affected. Both Stieglitz and Steichen struck into the rich vein of documentary-reporting. It shall not be forgotten that they were prophets and masters, whenever they chose, of the great "straight" tradition.

We are no longer so very occupied with the idea of status for photography. This is in part because Stieglitz gained that very thing for his chosen field. He put up quite a fight. He was photography's missionary.

It is known that Stieglitz had only one real pleasure aside from his work: that of dismembering and skewering rich, succulent Philistines—*au jus*.

Non-fiction Essays for *Fortune* 1945–1965

Between 1934 and 1965, Evans contributed more than four hundred photographs to forty-five articles published in *Fortune* magazine. He worked at the magazine as Special Photographic Editor from 1945 to 1965 during which time he also contributed five portfolios to *Architectural Forum*, which, like *Fortune*, was owned by Time Inc. After 1948 Evans not only conceived of the portfolios, executed the photographs and designed the page layouts, but he also wrote the accompanying texts. His topics included railroad company insignias, common tools, downtown Chicago, New York's Pennsylvania Station, industrial New England towns, old summer resort hotels, a Mississippi riverfront town in Kentucky, and views of America from the train window. Using the classic journalistic picture-story format, Evans combined his interest in words and pictures and created a multi-disciplinary narrative of unusually high quality. Classics of a neglected genre, these self-assigned picture and word essays were Evans's métier for twenty years.

[Manuscript List of *Fortune* Portfolio
Ideas], 1950s
WEA 1994.250.91 (21)

PORTFOLIOS

Agreed?:
1. Securities ~~engr~~ art
2. Old industrial views
3. Harbor Point, Mich.
4. Men's dress, U.S. historical
5. U.S. from the air, photos
6. NYC new skyline & bldgs
7. Roadside, motels, etc. 00
ADD:
1. Ocean liners to be scrapped
2. ~~Gentlemans farm~~ DILLO
3. Detroit pub. co. views
ODD DILLON

————————————————

QUESTION:
 3rd AVE.?

"Vintage Office Furniture," *Fortune* 48 (August 1953), pp. 123–127

VINTAGE OFFICE FURNITURE

by Walker Evans

There is probably not one brass cuspidor left functioning in the U.S. business world today. But the rest of the grand old office trappings are still to be found here and there, in any city that had a commercial life through the nineteenth century. The rolltop desk, the scrolled and lettered black-iron safe, the padded and studded swivel chair, the high oaken bookkeeper's perch—these you may see in daily use in old Hartford, in Cincinnati, New Orleans, or Boston.

Consciously or not, their owners gain a certain air of solidity for their premises through these furnishings, for some of them are masterpieces of traditional ornament and design. In downtown Boston, now, they may serve as the subtlest form of inverted deceptive, or backspin, grandeur—perfect for one of the great side-street trusteeships which controls possibly one-sixth of the state of Utah, two cinema palaces in Montevideo, and all the ships at sea.

A corner of the front office at Howell Manufacturing Co. (vinegars and extracts), Cincinnati

A Rolls-Royce among rolltops—senior officer's desk at First National Bank, New York

An accretion of atmosphere in Boston: the law firm of Tyler & Reynolds

The reasoned perfection of modern designers' office furniture was the subject of a FORTUNE portfolio of pictures last month. But has this subject another aspect? Are there men in hiding who *like* their old desks; who think and work extremely well behind them? The same men who cannot possibly put in an honest day's work while clad in a razor-sharp two-hundred-dollar suit of clothes?

Contemporary designers are perhaps the most triumphant group of professionals operating in the land today. They may alter the entire face of business in a matter of years now. When this happens, a photographic record like the collection on these pages will be wanted by historians.

Bookkeeper's desk, E. G. Whittlesey & Co., Hartford

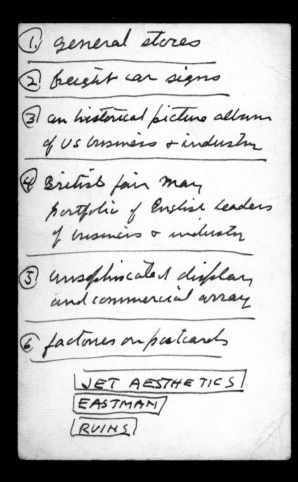

1. general stores
2. freight car signs
3. an historical picture album of US
business & industry
4. British fair May portfolio of English
leaders of business & industry
5. unsophisticated display and com-
mercial array
6. factories on postcards
 JET AESTHETICS
 EASTMAN
 RUINS

PORTFOLIOS

Idlewild Power Plant
Rooftops The Ruins of New York
Farewell to ships
The stencil Jail
Lettering Post Offices
Hudson River
Passing views caught
Bond engraving

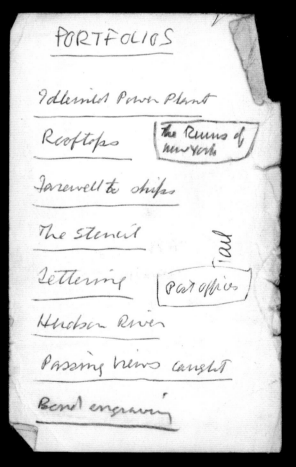

[Manuscript Lists of *Fortune* Portfolio Ideas], 1950s
WEA 1994.250.91 (21)

"Beauties of the Common Tool," *Fortune* 52 (July 1955), pp. 103–107

Stahls chain-nose pliers (over actual size), from Eskilstuna, Sweden, $2.49

Beauties of the Common Tool

A portfolio by Walker Evans

Among low-priced, factory-produced goods, none is so appealing to the senses as the ordinary hand tool. Hence, a hardware store is a kind of offbeat museum show for the man who responds to good, clear "undesigned" forms. The Swedish steel pliers pictured above, with their somehow swanlike flow, and the objects on the following pages, in all their tough simplicity, illustrate this. Aside from their functions—though they are exclusively wedded to function—each of these tools lures the eye to follow its curves and angles, and invites the hand to test its balance.

Who would sully the lines of the tin-cutting shears on page 105 with a single added bend or whorl? Or clothe in any way the fine naked impression of heft and bite in the crescent wrench on page 107? To be sure, some design-happy manufacturers have tampered with certain tool classics; the beautiful plumb bob, which used to come naively and solemnly shaped like a child's top, now looks suspiciously like a toy space ship, and is no longer brassy. But not much can be done to spoil a crate opener, that nobly ferocious statement in black steel, as may be seen on page 104. In fact, almost all the basic small tools stand, aesthetically speaking, for elegance, candor, and purity. —W.E.

Baby Terrier crate opener, by Bridgeport Hardware Mfg. Corp., 69 cents

Tin snips, by J. Wiss & Sons Co., $1.85

Bricklayer's pointing trowel, by Marshalltown Trowel Co., $1.35

Open-end crescent wrench, German manufacture, 56 cents

Mr. Walker Evans.

5 Rue de la Santé.

Paris V, France.

envoyer, s'il vous plaît.

return to H.S. c/o Dr. Fred Pfeiffer.
2311 Loring Peace. New York, N.Y.
U.S.A.

Corre-
spondence

The bulk of the correspondence in the Walker Evans Archive are letters sent to Evans from his family and friends, neighbors and lovers; from artists, art students, museum curators and private collectors. The correspondence file includes letters from many of the most respected writers, critics, and artists of the day including Diane Arbus, James Agee, Henri Cartier-Bresson, Ernestine Evans, Robert Fitzgerald, Robert Frank, Bernard Haggin, Wilder Hobson, Lincoln Kirstein, Jay Leyda, Dwight Macdonald, Ben Shahn, James Thrall Soby, John Szarkowski, and Robert Penn Warren. Evans carefully preserved and filed these letters (and their envelopes) in what he described as his "archive." He dated those that were undated and separated personal from professional correspondence. With an amateur archivist's zeal, he even had a file for "Unanswered Letters."

Evans's earliest correspondence is an exchange of more than 150 letters dating from 1924 to 1933 between Evans and Hanns Skolle (1903–1988). Skolle was a German painter, author, and during these years Evans's closest friend as well as a frequently absent but recurrent roommate. Evans and Skolle often wrote to each other weekly, exchanging commentary on a cross-section of contemporary authors, including works by James Joyce, D.H. Lawrence, Joseph Conrad, Thomas Mann, George Bernard Shaw, Hermann Hesse, Siegfried Sassoon, Ernest Hemingway, and Aldous Huxley. Stylistically inventive and witty, the letters are convincing evidence of the seriousness with which Evans took his nascent career as a writer. Integrated seamlessly into their dialogue on modern literature is equally astute commentary about recent musical recordings, documentary and feature films, and the daily experiences of two emerging artists in America during the early years of the Depression. At times the letters also have a distinct graphic flair, as Evans and Skolle often included humorous clippings from both newspapers and magazines which they affixed to their stationery and envelopes.

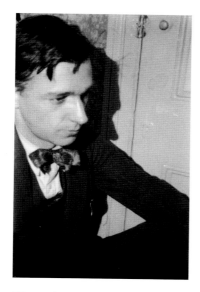

Hanns Skolle, *Walker Evans*, ca. 1928
WEA 1994.251.123

Hanns Skolle, ca. 1928
WEA 1994.251.124

During their friendship both men traveled extensively and their distance from and respect for each other generated a vital correspondence. Evans never wrote to anyone else with the same frequency, intimacy, and conviction. Aware of the importance of this communication, Evans kept copies of his letters to Skolle. By the mid-1930s, however, most of his friends lived in New York City and had telephones, and gradually Evans reduced the volume and intensity of his letter writing. Around this time, he also stopped putting his ideas into words and devoted his energy to photography instead.

The best of Evans's letters to Skolle are precisely composed essays; collectively they read as a conscious literary experiment similar in tone and composition to his short stories and prose-lists of the same period. They offer an intimate view of a young writer obsessed with books and their authors, one who over the course of nine years, trades his pen for a camera.

The correspondence with Skolle ends in the fall of 1933 when Evans shared a studio with another painter, Ben Shahn. Skolle was then traveling in Europe and Africa having succumbed to a lifelong wanderlust. It remains unknown how long thereafter the two artists remained friends.

[Self-portrait, 5, rue de la Santé, Paris], September 1926, 6.7 x 7.0 cm
The Metropolitan Museum of Art, Gift of Myriam and Harry Lunn 1995.560.1

Hanns Skolle to Walker Evans

Ossining, New York, to Paris
October 18, 1926
Manuscript
WEA 1994.260.26 (8)

Skolle wrote frequently to Evans in Paris and Antibes during Evans's year abroad in 1926–27. In a late July 1926 letter Skolle asked Evans how his "literary masterpieces" were progressing, to which Evans replied in a response which only survives in draft form on the back of Skolle's letter: "I don't write to you because my erstwhile dashing spirit is dormant. I am dead and disgusted. This won't do to put on paper. My self analysis is becoming self laceration; my failures call for such violent criticism (and get it) that I am in a fair way … to what? More revolte, a sort of super revolte … but I can't revolt against everything, including revolte. Ah, truth—I hate myself and didn't want you to know it. I am dreadfully sick, and a vain dire, a little desesperé. And the funny part of it is, I know exactly what I need to cure me but am too perversely lazy to go and get it. No, I don't think of suicide; I am ashamed of that too. Do you know what *nothing* means? There is something to discover. I think you do. Death is *something* you see."

Evans's crisis of confidence generated a well-reasoned pep talk by Skolle which glancingly documents Evans's earliest use of the camera.

Ossining, October 18, 1926

Yours, dear Walker, sound like the reflections of a manufacturer of artificial limbs with no war at hand. (Call me anything you like.)

I fear you made a deplorable mistake in destroying all your writing. Why incapacitate yourself? Especially when there is no immediate substance to take the place of the destroyed matter? Time enough for such radical decision later in the face of deeper, fuller, more complete creation. Don't remain implacable to the Muses, the only decent type of woman, made expressly for us noble knights of the mind.

As for dying, I say:

Come on you fire-trucks and milk-wagons, loosely hinged lifts and swaying bridges, shivering skyscrapers and rotten board walks: run over me, tumble down upon me, give way under my serenely treading feet; you are just as perishable as I am, just a matter of chasing each other to hell.

With such, and flying priests and Packard-driving nuns Christianity is at an end. A refined Heathenism sets forth: the new God wears a Stetson hat and carries in his pocket a perfumed ladies' garter for his own fetish while the worshippers glory in the prohibition of wine and die of bottled carrots.

But you dislike discussions on Religion and far be it from me to bore you with the holy ideas a generation of clergymen inadvertently handed down to me.

I expect to return to New York this week or the next. The paintings are finished, the money I earned spent on clothes and horses. Rode a great deal in Briarcliff and learned how to take hurdles.

One fine morning I rode a frisky little black horse which seemed to take a great fancy to me from the very start. On reaching the "open road" it jumped and trot and galloped much to my amazement, outdoing all his stable-mates. Riding home, however, the public eyed my droll colt with somewhat shocked demeanor,

reducing my proud satisfaction to wondrous distrust. At the stable, it was at once disclosed what disagreed with the public: my caressing thighs must have set the animal's imagination going in a sentimental direction for, when I chanced to look at the rear, I could not but admit an increase in his anatomy, fair competition for all the church-bells Huysmans ever braged about.

Upon my word, the photos you took of yourself are superb. The one 'en face' is truly a treat of a picture. I wish I could paint as well as that. My idea of a round bed, by the way, has been copied by a detestable Spaniard. (See clipping.)

Sorry you couldn't send the tropical helmet. Your suggestion of renting an apartment when you come back is very good. Maybe we could write a play together and become famous over night. Bring some champagne along and our brains will puff away ideas that will make Shakespeare look like Fannie Hurst. Made many new wood-cuts, most of the old ones are going to appear in the "New Masses." Weyhe wants to take all the new ones in commission.

Many of my Leipzig friends spend the summer in Paris. Which is your safest address?

Please write to me more often!

Hanns.

What about the mysterious V after Paris?

c/o Dr. Fred Pfeiffer
2311 Loring Place
New York, N.Y.
U.S.A.

"Weyhe": Erhard Weyhe (1882–1972), German émigré and proprietor of a
Manhattan bookstore and gallery
"mysterious V": See address on envelope (p. 118), which includes
the indication for Paris's fifth arrondissement.

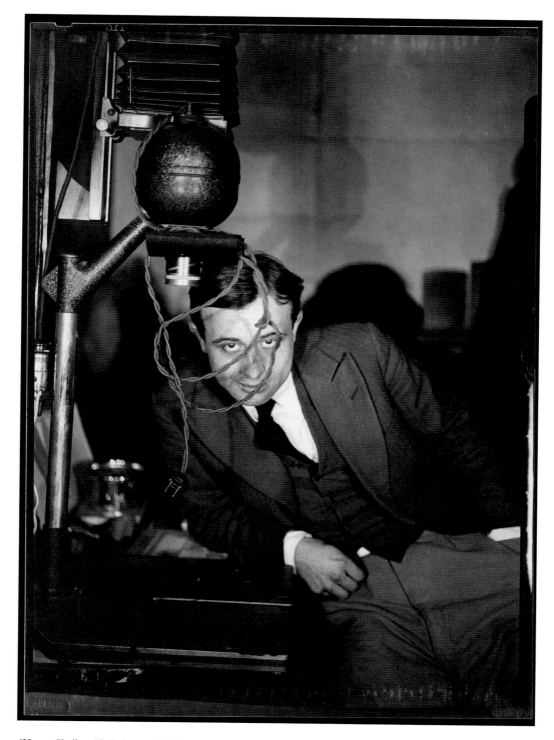

[Hanns Skolle with Enlargers], 1929–30, WEA 1994.255.7

Unknown Photographer, [Walker Evans, The Berkshires, Massachusetts],
August 1928, 3.7 x 6.1 cm, The Metropolitan Museum of Art, Purchase, The Horace W. Goldsmith
Foundation Gift 1996.166.31

Walker Evans to Hanns Skolle

Ossining, New York to Sharon, Connecticut
August 14, 1928
Carbon copy of typescript
WEA 1994.260.25 (3)

After Evans returned from France in May 1927, he and Skolle shared an apartment in New York City; consequently they wrote no letters to each other until the following summer. Convalescing after stomach surgery in June, Evans spent the summer and early fall of 1928 in Ossining, New York, growing gladioli—a curious enterprise subsidized for at least two summers by his father, an amateur horticulturist. Skolle spent August nearby in Sharon, Connecticut, the guest of Bertram Elliott, a painter. D.H. Lawrence had just published *Lady Chatterley's Lover* and the two men spent the summer reading and discussing Lawrence, Jack London, Dostoevski, as well as the relative merits of the photographic portraits they made of each other.

Dear H:,

 Your letter admirable, in parts; I believe the postscript
is one of the best things that has appeared.

 I will answer your queries, backwards:
 2. Yes, your wood-blocks are available; they are not
 even in the attic here, but clutter up my closet floor
 so that if I had as many shooz as a gentleman should
 have they would be in the way. The wood-cuts or the
 shooz? Both, Watson.
 1. The Modigliani book is published by the Editions
 des Quatre Chemins. In Paris.

 Would you like to visit me for a time? Say the word and
I'll drive up to get you. There are at least two diversions here
now. Discovered them both in the last few days. One: that pool at
mid-day, when it is deserted,until two o'clock. Another:a game
played with an ice-pick. I invented it this evevning. There are
two ice picks in our house. One is decorated and is obviously
meant to go into the ice-box of a young married couple the girl
of which would call it cute or sweet or adorable because the knob
is half robbin's egg blue (for happiness) and half white (for clean-
liness and purity); this evening I found this here ice pick so
God damned cute that I threw it across the kitchen and threw it
hard. Now, Mister, you wouldn't think it, but that was the begin-
ning of Throwtheicepick patents pending the world over. The point
is that the thing travels through the air point first, sticks in
doors, trembling dramatically the while. Just walk across the room,
casually; suddenly, whirl about and sling the insrument instrument
at a portrait of Cal Coolidge hung on the door. My greatest achiev-
ment this evening was a terrific throw which sent the thing right
through the door, so that a good deal of the point stuck out on the
other side. Come and we will play this game.
 There are also two girls to swim with and take riding.
I don't know them very well but find that they will do very nicely
for that sort of thing. Come and we will play that game too.

 p.s. HEMORRHOIDS TRACED IN JOHN GALSWORTHY

 "HEMORRHOIDS TRACED IN JOHN GALSWORTHY": Skolle had closed
his previous letter to Evans with a postscript composed of a thin newspaper clipping
glued to the bottom of the page: "RICKETTS TRACED IN DANTE."

Walker Evans to Hanns Skolle

Brooklyn to Denver, Colorado
January 25, 1929
Carbon copy of typescript
WEA 1994.260.25 (4)

Hanns Skolle to Walker Evans

Denver to Brooklyn
January 29, 1929
Manuscript
WEA 1994.260.26 (47)

Brooklyn Bridge, 1929, 14 x 22.9 cm, Private collection

Evans and Skolle exchanged this pair of letters just after Skolle departed for Colorado where he and his wife Elisabeth would live off and on for several years. The separation generated a massive letter writing campaign. With Skolle away, Evans assumed his friend's lease on an apartment in Brooklyn at 48 Columbia Heights, just steps from the poet Hart Crane's at 110 Columbia Heights. At the bottom of the street stood the Brooklyn Bridge—the subject of Crane's epic poem *The Bridge* (1930). Evans was also drawn to the structure and Crane included his younger colleague's photographs in both the French and the U.S. editions of the book.

48 Columbia Heights
25 January, 1929, nom de Dieu

Dear H.

Thursday spent fuguring best way to pass off departure
of my melancholic companion. Dropped in at Haaga's and found
you weren t missed yet there. Simple souls! They think every-
thing is as it was. Dashed up to talkative picture framer.
As soon as I put in appearance , and before I opened my mouth,
he emerged from backshop holding Brooklyn Bridge. What flattery;
left him with his illusions intact.

Galdstone was so touched (and sincerely, let me say; I
could see it through his violent efforts to make me believe it)
by your gift, the mask. He looked at his gold wrist watch and
at his platinum pocket watch, uttered choice literary words in
four languages, stepped on the dog and gave me a drink. Also
$1.25, herewith.

Very casually returned to 48 Columbia Hites, put on
Clair de Lune and fell to cleaning up the place, noting dif-
ferent items of my inheritance as I went along. Six trips
to garbage can.

Friday evening got some spinach on the ceiling. Geyser.
Read Chatterly and typed out some passages from it for your
benefit.

Saturday arrived home to find your letter, good. Better
have saved Calabria for more comfortable occasion. It is a
fireside book.

Await with tension your next.

"Haaga's": A grocer in Evans's Brooklyn neighborhood.
"Galdstone": Dr. Iago Galdston, a dentist and amateur photographer,
lived nearby Evans and Skolle in Brooklyn Heights.
"Calabria": Norman Douglas, *Old Calabria* (London: Martin Secker, 1930), first published in 1915.
Skolle had complained to Evans that this travel story was ill-suited to his train trip to Chicago and Denver.

Dear W.:

Highly pleased with your letter. Do that sort of thing in a more impersonal way
for literary purposes. To me, of course, the local touch seems particularly cunning.
I haven't had such a hearthy laugh in a long time as over the spinach on the ceiling
on Friday night and the six trips to the garbage can.

The five lines on Gladston are a piece of perfection. And the situation at
Haaga's is quite dramatic, especially:

Simple souls! They think every thing is as it was.

There you certainly have it! May I reward you with that dirty pair of pyjamas
which you must have found on my table? They will look like new after a good
cleaning.

My best to the doctor and Grotz.

H.

"literary purposes": Evans took special note of Skolle's response to his letter. His
short story "Brooms" (see pp. 62–65) is the result.
"doctor": Iago Galdston
"Grotz": Paul Grotz (1902–1990), German born architect
and art director at *Architectural Forum*

Hanns Skolle, [Thank-you note for
Walker Evans], 1928, ink and watercolor
on board, WEA 1994.250.91 (16)

Hanns Skolle, [Fruit Stand,
New York City], 1928, 10.2 x 6 cm,
WEA 1994.263.17

To WALKER EVANS

In greatful Acknowledgement
of efficient Services rendered
the Year of Our Lord 1928.

H:

Your second letter arrived this morning. Enjoyed it thoroughly, must thank you especially for that touch about the height of the sky in Kansas.

Synopsis of Lady Chatterly's Lover I'll send along. It's not finished.

With your letter came a knote fromme Ena asking me to dine, which I can't do, having got me a new job working from five to midnite or thereabouts. Shall see her Sunday, though. The job is excellent, just what I was looking for: cut-and-dried, not much work, no women, gives me all day free.

Blowing home late the other night I came upon the doctor, wrapped in xxkx pseudo polo coat, looking at the moon thru pr of Zeiss glasses picked up in Milano for abouttt' 8 $ sent to Germany to be repaired; anyway, a bargain. The moon, of course, costs nothing, but one must have the glasses to transform it from cheese into ghastly blotched ball floating in silent ether. I looked at it too; that damn thing up there, cold. Then the doctor and I had a drink and a kind of conversation - his kind. By the way, your watercolor is much appreciated by all his friends. Of course he is tickled to death.

```
Thanks for:

    ruler
    Rosmersholm
    Superior clips
    Vick's Vaporub
    twine
    India ink
    Asia
    monocle
    Sterno
    The Missing Link
    hatchet
    oil can
    Dos En Uno Pasta Superior

No thanks for:

    Le Pages Big Boy Paste
    The Miraculous Revenge, by Bernard Shaw
    Rock Island time table
    garbage
    Burton's pure trade purity strength delicacy of flavor
mark extract of vanilla
    souvenirs of amorous adventures
    "whiskey"
```

Walker Evans to Hanns Skolle

Brooklyn to Colorado
January 30, 1929
Carbon copy of typescript
WEA 1994.260. 25 (5)

```
                      yrs
```

"sky in Kansas": Skolle wrote to Evans on January 23 aboard the train from Chicago to Denver: "We are now putting through Kansas. Nothing but brown and yellow, the sky hangs too low …" WEA 1994.260.26 (44)

"Ena": Ena Douglas, friend, appears later as a character in Evans's short story "Brooms."

"new job": Evans sorted securities at Henry L. Doherty Company, a Wall Street brokerage house.

"the doctor": Iago Galdston

"Rosmersholm": Henrik Ibsen's play from 1886

"Asia": *Asia Major*, journal devoted to the study of the languages, arts and civilization of the Far East and Central Asia, published in London and Leipzig, 1924–1935

Walker Evans to Hanns Skolle

Brooklyn to Denver, Colorado
February 6, 1929
Carbon copy of typescript
WEA 1994.260.25 (6)

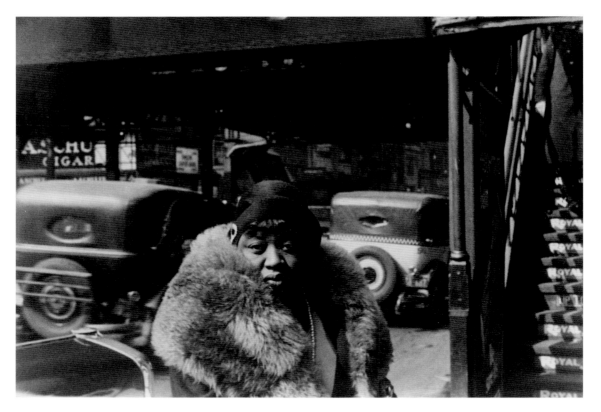

42nd St., 1929, 16.2 x 24.0 cm

The Metropolitan Museum of Art, Ford Motor Company Collection,

Gift of Ford Motor Company and John C. Waddell 1987.1100.68

Dear H.

Your two letters, having raced each other across the continent, arrived together in splendid condition. Especially the one engraved on sheet no. 18, which I am having framed.

Where did you get that photo of newlyweds posing? Parfait!

D.D. is Doctor of Divinity, and rather dangerous. Take care. Theological degree.

Received Old Calabria, sheepishly.

And which clipping on Lawrence did I send you? Because I have been doing him in a letter for you (as yet unfinished). I shall probably repeat myself.

I am only writing you today because your two of the 27th have been so long unanswered; fact is I've the Chatterly stuff, some pictures, and two or three pages of nonsense I want you to read - all unready to send.

Situation very satisfactory here. Alone all day until teatime; much possibilities. Photography encouraging lately. Last night sat late after work reading that wonderful chapter headed "Waterparty" in "Women in Love." Do you remember it? The drowning incident, the frantic supernatural atmosphere all along.

I want to hear about Denver now. The facts. The details. Photographs of anything you do.

Perhaps you'd better send me that little camera when you can get yourself one. Didn't you take any snaps on the trip out? In sending it, best get a wood box and fill in space tight with cotton.

Hanns Skolle to Walker Evans

Colorado to Brooklyn
February 11, 1929
Manuscript
WEA 1994.260.26 (50)

BROOMS is remarkably good. Certainly the best thing extant. Congratulations! The apparition on the last page is a trump, the final sentence the finest you have let loose, the puns are matchless. It's a very well concentrated piece of work showing no effort. Perhaps I should either leave out or substitute: "Rot. Thought gets in my way." This isn't aloof enough, the 'plot' being so delicate. Besides, it counteracts "Divine power of thought" unpleasantly, this being very strong right after " ... and therefore unmentionable."

I am not so sure of my unimportant corrections, though I would mention Haaga's profession for the benefit of the uninitiated reader.

The paragraph "Upon one of the main thoroughfares ..." comes off beautifully.

I take it for granted that this copy is mine. Please sign and send it back to me Twang away, Muse.

H.

P.S. February 11, 1929.

"BROOMS": Evans had sent Skolle his short story "Brooms"; see above pp. 62–65.
"unimportant corrections": Evans made all the changes Skolle suggested.

BROOMS

is remarkably good. Certainly the best thing extant.
Congratulations! The apparition on the last
page is a trump, the final sentence the finest
you have let loose, the puns are matchless.
It's a very well concentrated piece of work
showing no effort. Perhaps I should either
leave out or substitute: "Rot. Thought gets
in my way". This isn't aloof enough, the
'plot' being so delicate. Besides, it counter-
acts "Divine power of thought" unpleasantly,
this being very strong right after "..... and
therefore unmentionable".

I am not so sure of my unimportant
corrections, though I would mention Haaga's
profession for the benefit of the uninitiated
reader.

The paragraph "Upon one of the main
thoroughfares..." comes off beautifully.

I take it for granted that this copy is
mine. Please sign and send it back
to me.

Twang away, Muse.

P.S. February 11, 1929.

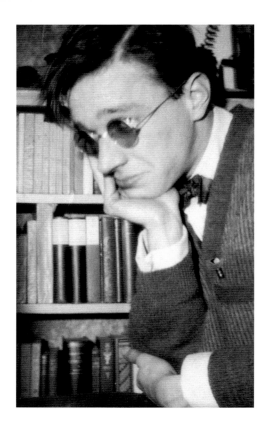

Walker Evans to Hanns Skolle

Brooklyn to Denver, Colorado
February 1929 [dated 1928]
Carbon copy of typescript
WEA 1994.260.26 (7)

Unknown Photographer, [Walker Evans in
Apartment at 48 Columbia Heights, Brooklyn,
New York], 1929, 6.0 x 3.7 cm
The Metropolitan Museum of Art, Purchase, The Horace
W. Goldsmith Foundation Gift 1996.166.28

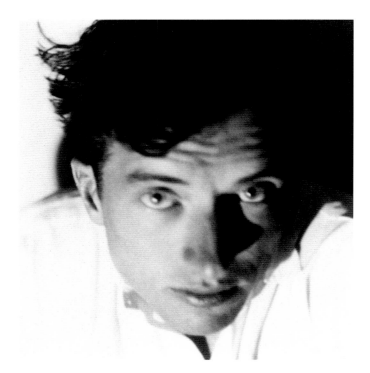

Paul Grotz, ca. 1929, 10.8 x 10.5 cm
The Metropolitan Museum of Art, Anonymous Gift 1999.246.18

just reaching for the typewriter as it were (and it were)
when postman left your latest.

but first: most encouraging, that letter of yours about
BROOMS. I have lost the mood, but when it comes again I'll
go over it with your suggestions. So, I'll keep the copy
you sent back for a while, because of your notes on it.

your notes on Denver I read with joyous chuckles; the sort
of rousing entertainment I find myself unable to offer here
this morning.

Living alone is so pleasant, I am considering putting off
Paul Grotz. My job: at four-thirty I have bangup tea, at
five I enter big office, no cheers. I am handed, instead,
pkg of bonds on which are written knames; and a list of
knames. Then I match them until seven, when I begin to get
hungry. Dinner is at eight, so I read SONS AND LOVERS.
From nine to midnight or so there is more of same. Then
dramatic passage under East River, me standing in front
vestibule of train in exaltation. Hot Ovaltine (nothing
like it for exaltation); puttering around amid books papers
photos memories and chagrins; bed.

My long awaited one volume edition of THE MAGIC MOUNTAIN
came from London. It is just right; you'll have to have one.

There is a family in France whose name is 1792. There are
four sons: Jaunury 1792, February 1792, March 1792, and
April 1792. March 1792 died in September 1904.

"SONS AND LOVERS": novel by D.H. Lawrence published in 1913
"THE MAGIC MOUNTAIN": novel by Thomas Mann first published in 1924;
in 1929 Mann would be awarded the Nobel Prize for Literature for this book.

Walker Evans to Hanns Skolle

Brooklyn to Denver, Colorado
March 17, 1929
Carbon copy of typescript
WEA 1994.260.25 (10)

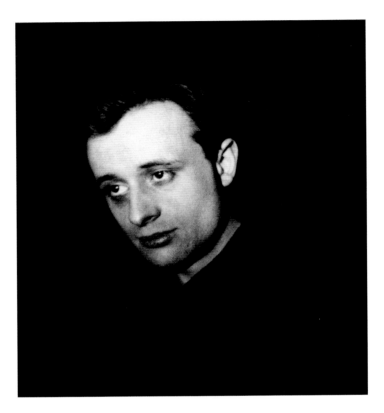

Hanns Skolle, ca. 1929, 8.2 x 7.2 cm
The Metropolitan Museum of Art, Gift of Mr. and Mrs. Harry H. Lunn, Jr. 1990.1055.1

"I waited so long": Skolle had repeatedly asked Evans about these photographic
portraits since his departure for Denver in January.

Dear H,

The last number of Asia which I am sending will cheer you with its article on pure-bred Arab horses. You will have received the enlargement of you as Hamlet which I sent last week. I ought to explain why I waited so long to send it, and why I am sending the others we took only now: I saw what a good enlargement the Hamlet would make but hadn't the money to get it done; and I wanted that one picture to crash into your consciousness alone, instead of weakened by the others.

No news. I'll soon be through working. Am in for another summer of gardening, but it won't be as bad this time. In fact I shall enjoy it, perhaps. Don't yet know where I'll settle. Please send me Bert Elliott's address; also the address of your sister.

Saw Steiglitz again. He talked at length. He should never open his mouth. Nobody should, but especially Steig- litz. He showed me some excellent photographs he had made: clouds, wet grass, the rump of a white horse, the bark of an old tree. As an example of his overstatement: he said of the tree bark photo: it was YEARS before I DARED do it.

The enclosed photo I clipped from the Times some time ago. You may have seen it. Could hardly be better, could it? It is a village magic-man in Belgian Congo; sort of medicine- man, healer; doctor and preist combined.

Please let me know what you are thinking of doing this summer.

Darien, June 28
1929

Dear H

Yesterday morning in the sunlight while otherwise
engaged physically, mentally I composed a remarkable
letter to you. I sit now in the afternoon lethargy of
another day, not attempting an earthbound transcription
of those thoughts. Consider yourself their object, merely.

Merely!
Merely?
Merely.

The cactus arrived, I am much pleased to have it.
It threatens to bloom. Masterly packing noted.

Did you get sick of Paris? I have written a letter
of introduction for you to Jan Sikorski. Now I find
this won't reach you in Paris, so I am sending it to
Germany, enclosing the letter to S, on the chance that
you will be in Paris again. S is decidedly quelqu'un.
You might find him at the offices of the Monde Nouveau,
if that still exists, on Boul Raspail; look it up. He
lived at No. 10, Rue Asselene, which is a sort of hidden
street off the Avenue du Maine, somewhere in the quarter
back of Gare Montparnasse. S speaks German or French or
English. Ask him to show you his watercolors.

Did you ever see Stieglitz' photographs in the
print room at the Metropolitan? He has a portrait of
O'Keefe that must be one of the best things I'll ever
see. Great Guns.

I have read the much talked of IM WESTEN NICHTS

NEUES. Very strong, very good.

I have just redeived your card from Havana. Did you have much time there? Your adventurer Booth sounds interesting.

There is a Brunswick record of Scriabine ETUDE OP 2 played by one Hilsberg which is the best seventy-five cent investment I ever made. I wonder if you know it. To me it is very enigmatic, reeking with an indescribable atmosphere every bit as haunting as certain Poe stories. I have also the xxxx lovely Debussy REVERIE with JARDINS SOUS LA PLUIE on verso. Next week, on your recommendation, I am getting the Prokofieff LOVE FOR THREE ORANGES.

I hope you are planning to stay some time here next fall. You might sttle down, do some work. Everything is set for it: automobile, music, books, noe worry about getting enough to eat; cameras, la nature, my company. I'd be only too pleased to have you as guest all winter. You could give me some paintings and help wash the dishes.

J'attends des lettres copieuses.

Walker Evans to Hanns Skolle

Darien, Connecticut to Paris
June 28, 1929
Carbon copy of typescript
WEA 1994.260.25 (18)

"sick of Paris": Skolle spent the summer of 1929 traveling in France and Germany.
"Stieglitz' photographs": In fall 1928 The Metropolitan Museum of Art acquired twenty-two photographs by Alfred Stieglitz. Evans may have learned about the museum's acquisition of Stieglitz's photographs from Alma Wertheim, a friend of Skolle and donor of two of the seven portraits of O'Keeffe. The museum exhibited the photographs in February–March 1929.
"IM WESTEN NICHTS NEUES": Erich Maria Remarque's 1929 novel about World War I, *All Quiet on the Western Front*.

Walker Evans to Hanns Skolle

Brooklyn to Lamar, Colorado
May 13, 1930
Carbon copy of typescript
WEA 1994.260.25 (28)

"Maine or Mexico": Many of Skolle's letters in early 1930 include entreaties to Evans to join him on a road trip to Colorado, the Southwest, or Mexico; May 10: "Drive halfway, sell your Ford, take the train and let me call for you some place. We might go down along the Mexican border somewhere, roughing it …" WEA 1994.260.26 (95)
"Pornography and Obscenity": novel by D.H. Lawrence first published in 1929.

Good letter, postcard. Well; something must come off this
summer. Maine or Mexico. I really don't know how I am
going to be fixed, though. Doubt that I can take more
than a month. Why can't you make a trip east practical?
Bring all your work. Dear generous Herr Weyhe will do
pissiness for you, ya? Youve got to have a show next
fall anyway. Better come and arrange that. Will you
spend next winter in New York? Is that job of yours
going on again next year?

I'll pick you up in Chicago, huh? wynot; July 1st.

I know a consumptive lady litterateur in Mexico who knows
everyone down there: Orozco and that mural guy and Tina
Modotti and the literary blokes and the bombthrowers and
she says I can come and paint and photograph and write
and throw bombs almost freely. Wish I knew the lingo.
Where is the Portlandt Tceiment phactry?
I am reading a little and playing a little pingpongh.
A letter from the Paul Grotz who and wife does not prosper
in yurrup.

Send photos of work. By the way I am getting pretty hardboi
led about art dealers and business guys in general so wynot
send me some watercolors if you can?t come yrslf? Me agent,
see?

Had a wonderful dream last night. Where in hell do all
those details come from. Really, literature, all the
greatest descriptions I know are so much watery smudge
to the least of my dreams. I suppose the best about
dreams is the abolition of time. After one like last night's
I spend the day tasting the tail ends of lovely unearthly
moods without a headache. I think my powers lie mostly
there, in dreams.

J had a letter from a guy in Germnay in wonderful Englisch.
J am keeping it to show you. J can't find it now or J
might send it on, as a drop in the shower.

You may keep Pornography and Obcenity. Don't throw it
away, it is a first edition. I have another.

Walker Evans to Hanns Skolle

Brooklyn to Mexico
June 19, 1930
Carbon copy of typescript
WEA 1994.260.25 (29)

"bloody country": Eight months after the stock market crash on "Black Thursday," October 24, 1929, the country was in the throes of an economic and moral depression. Unemployment and homelessness were rampant: by March 1930 the government estimated that there were between 3.2 and 4 million unemployed Americans; a year later, the number had doubled.

"transition": literary monthly edited by Eugène Jolas and Elliot Paul and published in Paris and The Hague from April 1927 to Spring 1938; no issues between summer 1930 and March 1932.

"Ena": Ena Douglas

"Katherine Anne Porter": American writer (1890–1980) and neighbor in Brooklyn; published *Flowering Judas*, her first collection of essays about Mexico, in 1930.

"Slater Brown and Crane and Coates": The writers Slater Brown and Robert Coates were friends of Hart Crane.

Dea H,

Good . I think you are clear f this bloody country. And
if Mexico cna't finish you, nothjng will.

Of the two little compositions which I failed to acknowledge
Much the better id BAGARRE A LAMAR. In fact, I suspect the BAGARRE
A LAMAR is altoether something. In spite of the sahadows of Oscar
W lde and h Baudelaire. This piece i take as a seriou thing
since it c ntains real flashes of your dreadful mentality. But
CHRONO ETER doesn't quite come off, for me. Still, "Good day, for
good." is great. CHRONOMETER is greatly to laughh , of course, be-
cause I m sure it's strictly autobio raphical.

Didn t know you were a French stylist.

Body deflated and mind underspirited today. Rather happy to
be broke again, though. Makes getting up in the morning and thinking
cav rnous thoughts anecessity. Couldn't say what happened to Phila
delphia. Mysterious of them to throw me hundreds of dollars worth
of prostitutuon, make a fuss over me, then shut off. Now I ll have
to storm the New York agencies, God help me.

By the way, I have two pretty cousins. Alas, impossibly
ladies. I mean such well bred. I mean they can dance like a streak
but they go to college. I mean there was a party in shirtstuds with
music and a rich father in the advertising business and the view was
magnificent of city fog two a.m. hushed distant air thick with me
aloof and other things going on other places for the imagination.
Next week, then, I will become business.

Transition has issued its final nimber. I am going to pub-
lish some hotographs in oreder to become known and make someone
exhibit me and sell prints and make money and take leave of certain
malaise. There is a new book about Bali which is just about what we
should be doing or by now have done The Last Paradise by Hickman
Powell photographs by Andre Roosevelt at all bookstores $4.00
Jonathan Cape and Harrison Smith New York.

Other news I have been to Cape Cop quite good place with a
Jewish painter whom I like ad had a sunstroke in a peculiar land-
scape making photographs without a hat; there is a sort of female
mixup now going on continuous performance; Bernice Abbott let a
French p blisher have some of my best photographs for a book and
I am furous because that is a totlal loss all around and I am going to
try to cable nothing doing; all this very tough on Knerves. Paul
Grotz os building a hotel in the mountains of some European country.
Firther news not worth recording ecxept that I have some photos in
international (Lichtbild) exhibition in Munich.

Your going to Mexico complicates perhaps a little plan of
mine to present cetain phptos of mine. Do you think they would get
through o k? I'm just about ready to send them. Want your r action
and need criticism. Have certain things I know yu will li ke.

Please plan to let me have full letters. I wull want to
hear a lot about that place and your doings. Regards to Ena. I
promise to write often if you will. Do the Mexicans open letters?
What a bore if they do because they will never make ours out
and will throw you in jail as suspicious.

Send me a definite address as soon as possible. Or would
poste restante be safest? However I want your living quarters
for telegrams and phone c lls. And so forth, according to the
whims of modern science. I will try to locate Katherine Ann Porter.
Who knows people in Mexico and is there now. She writes things and
belongs to revolutionists but is quelqu'une and woud be gl d to see
you. Her friends in New York are Slater Brown and Crane and
Coates and so forth if you know whatI mean.

[Window, Wellfleet, Massachusetts], 1929–31, WEA 1994.255.277

[Cabin, Oak Bluffs, Martha's Vineyard, Massachusetts], September 1931, WEA 1994.255.294

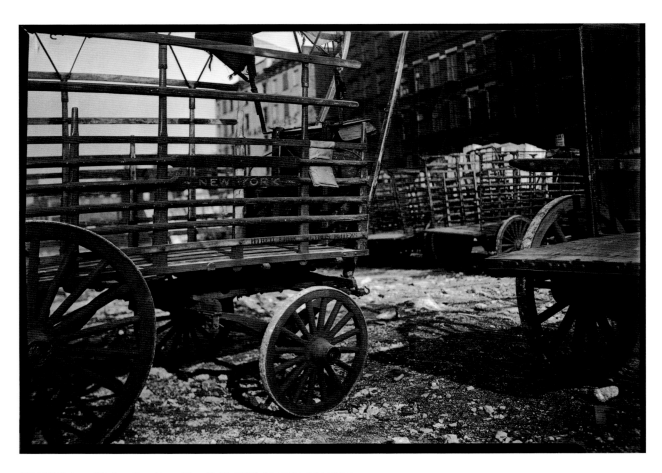

[Old Wallabout Market, Brooklyn, New York], 1930–31, WEA 1994.255.84

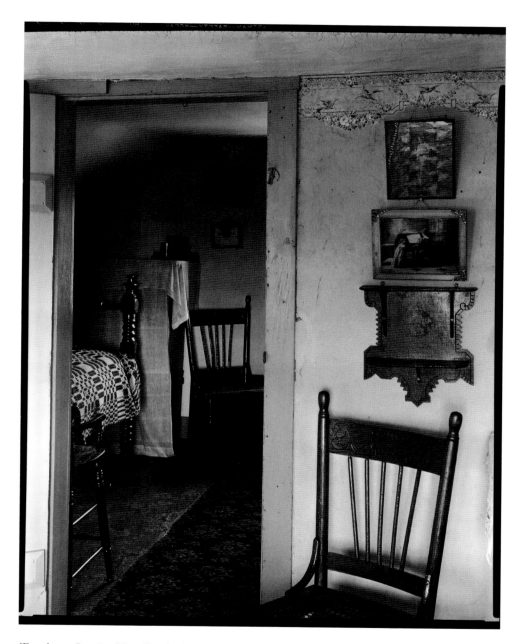

[Farmhouse Interior, Near Copake, New York], 1933, WEA 1994.256.84

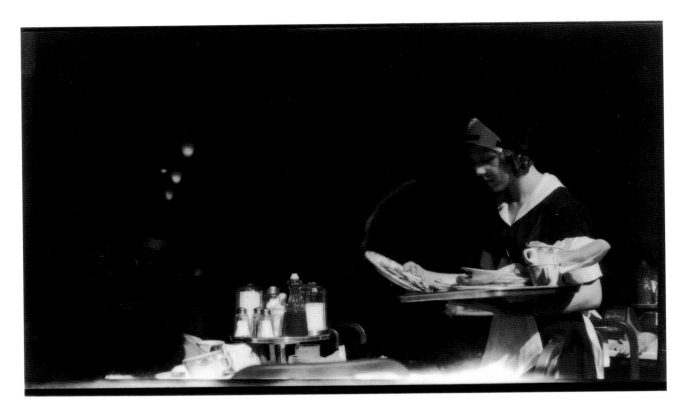

[Waitress in Window, New York City], 1928–30, WEA 1994.251.334

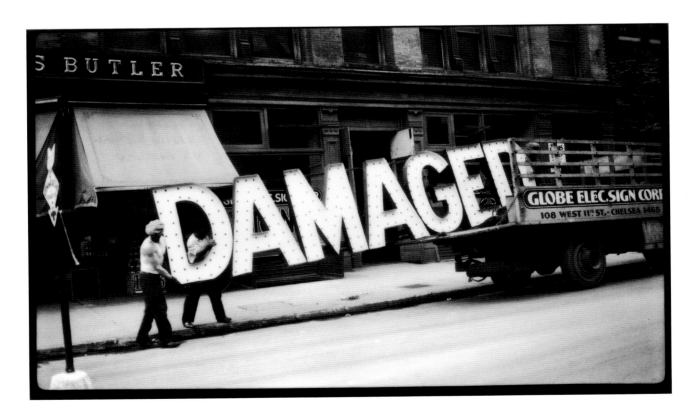

Truck and Sign, 1930, WEA 1994.251.283

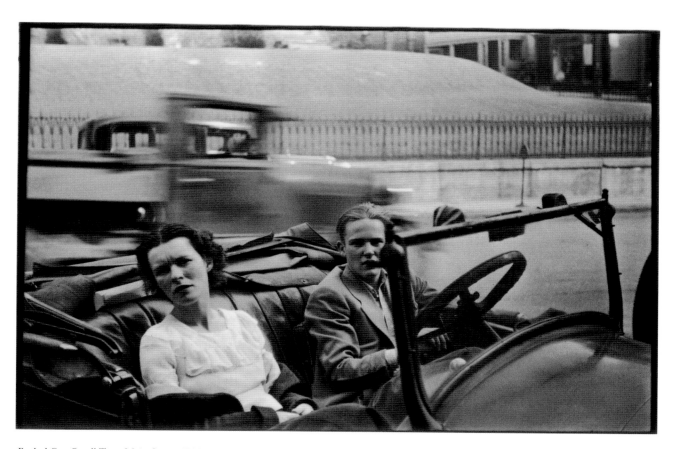

Parked Car, Small Town Main Street, 1932, WEA 1994.253.215.1

America, July 4, 1931

Dear Hanns,

I notice you are dating your letters. And that your taste in news clippings remains firstrate. The deux hommes ordinaires (sic) hanging on the boxeur argentin are worth framing.

New-York, as the French say, is still maddening. In it I can act only in desperation. Have done little since you left. Augmented the series of Victorian architecture photos with a rather better series, during a second trip to Boston. At present I am about to move; will have to have a place where I can work and sleep (not live, note). And try to make some money. Summon my most hard-boiled manner.

Ralph Steiner the photographer has turned out to be most generous, and has offered to teach me photography. He is a bitter little Jew, intelligent, whose limitations are skillfully blurred. Probably not clear in his own mind about what he is doing (he can make money with tragic ease). I will let him work on me as much as he likes. He has made a few of the best street snapshots of people I have seen, but doesn't show them. People greeting one another, showing off, et eet. Not enough done, though. Like all superior Jews, he has married an inferior Nordic who has pushed him in the wrong direction.

Paul is still out of work but seems better than he was. I think his most serious problem lies elsewhere, anyway. After all, he will catch on somewhere, sometime. I have been staying with them, but long enough now.

Good news from you, latterly. Your first letters were sad enough. I am so pleased to hear you have been swilling wine and sweating it out on the tennis court. To 50, Rue Mons. le Prince I sent a book called Decline and Fall, author of Vile Bodies, indeed a good book, indeed excellent splendid which I am sure you never received it alas. And on the other hand I am reading the Outline of History after having seen your letter to Miss Chamberlain thanking her for the Outline of History. It is not a good book don't you think but in spots such as prehistoric history and extraordinary facts about birth of art and marvelous hints of men doing in concert, rythmically, purposelessly all those things, and descending to the XXth century still that way only more so; in this respect a fascinating conglomeration. Wells is such a funny man about improving the race. I am unable to understand his approach. Not a poet, not an artist, not an historian. Just a goddam little socialist I suppose. Me, I am a Facisti and I think the human race should be kiked around a great deal more than it is, and that I should do the kicking. It is sad that men like Well and B.Russell and Shaw too, who can get into things brainfully, should come out of them that way. I am told Spengler is the guy to investigate from our point of view.

There is no news. The country is magnificent for the senses, offering smells of greenery and faroff noses of train whistles going still farther off, objectively of course. I always sit quite still under the circumstances. Now tell me what is the present status of the French neurosis. Transition is to reappear with a capital T, I have heard. A very good book is Seigfreid Sassoons Moemoirs of a Foxhunting man. Effortlessly undertoned piece of real literature. I will send it to you because I want to see what you will think of it and because you will be captivated.

I will at this point close and hope for speedy undeserved response. Add that by chance was walking across 14th Street Avis Ferne the artists model and that rumor has it K.T. Young the tragedienne is in town but that would be another matter to encounter in traffic.

Walker Evans to Hanns Skolle

Brooklyn to Paris
July 4, 1931
Carbon copy of typescript
WEA 1994.260.25 (31)

"Paul": Paul Grotz
"Vile Bodies": novel by Evelyn Waugh, 1930
"Outline of History": history by English novelist and sociologist, H.G. Wells, 1920
"Spengler": Oswald Spengler, German philosopher and author of
The Decline of the West, 1918–1922, which predicted the eclipse of Western civilization.
"Memoirs of a Foxhunting man": first volume of a
semi-fictional autobiography by English poet and novelist, Siegfried Sassoon, 1928
"K.T. Young": Kathleen Tankersley Young, American writer who published two poems in
the Fall 1930 issue of *Hound & Horn* in which Evans also appears.

Walker Evans to Hanns Skolle

New York City to Paris
October 2, 1931
Carbon copy of typescript
WEA 1994.250.25 (32)

Skolle lived in Europe in 1931 attempting to avoid the consequences of the American Depression. In September, however, his wife "Lil" returned to the United States while Skolle continued to travel. Skolle included with his letters from this period numerous snapshots of Mediterranean scenes made with Evans's borrowed Kodak.

"Jane": Jane Brewer, Evans's sister
"the Dane": Peter Sekaer (1901–1950), Danish graphic designer and photographer; in 1935 and 1936 Sekaer would assist Evans both with his darkroom work and on the road in the American South. Sekaer was later hired as a photographer for the Rural Electrification Agency and the Bureau of Indian Affairs, both New Deal agencies.

Dear Hanns

Just back in the city. I hear Lil will
arrive soon, will be on hand with the ford if pos-
sible anyway with self. Provincetown excellent.
I was there a month, with side trip to Martha's
Vineyard, which I think I told you ablout. If I
didnt, know ye that there is on the island a
tabernacle in center of little village of cottages
wood built in 70's about, jigsaw-gothic and complete-
god damn nuts and very funny to see. Naturally there
will be photographs and will send some. Am working
now on many films form the whole trip.

New York is at its best due to October.
Brilliant activity on all sides and in the air.
Exhibitions publications auditions intuitions. I
muself am felling fine and my typewriter is rather
brilliant tonight dont you think? The laterst news
is that I earned sebenty five dollars and my thelephone
has been shut off and there was a burglary at the Grotz
apartment and they are moving into another here at
63 Park Ave and Jane is not yet protuberant although
three months with and Paul and I drank your health
in the Ossining bar with all the auto racing photos
and my mother has a pretty but nice young girl living
in her house. Oh yes and the Dane showed up and scared
my mother and my mother scared him while I was away
so I havent seen him but he is still nuts in the best
sense of the word and pretended he wanted to find you;
he is a signpainter in the suberbs of Peekskille.
Well and I am glad to be back in the city and to get
mail and go to the newsreel theater and to eat breakfast.
The world as you may know is about to collapse and what
I say is it jolly well deserves it but you ought to
see the new Waldorf Astoria the sixty billion dollar
hostelry on Park Ave at 48th St, City and I thonk I
mentioned the view from the Empire State buildingh.

There was a postal card from you at the Brewers,
so our correspondence is getting on. And in a letter
also from you, forwarded to me in Truro you say you
cant really agree with me but I forget what about so
thats all right. By the way Ben Shahn once met Youry
Bilstin on a bloomin ship somewhere; he was telling me
about a guy he met named Youry Bilstin and he said
you probly heard of him and I said XXXX YOURY BILSTIN?
I'll say I've heard of him;so the world isnt so large.

W

Walker Evans to Hanns Skolle

Hawaii to Europe
April 4–7, 1932
Carbon copy of typescript
WEA 1994.260.25 (34)

Evans left New York on a four-month journey to the South Seas in January 1932. Hired by Oliver Jennings, a New York industrialist, to join him and a dozen guests on board the *Cressida*, he made both still photographs and a film of the journey. Upon his return, Evans completed *Travel Notes*, a ten-minute silent film of the rhythms and patterns of Tahitian dance and travel by sail. This letter was written and mailed from a port in Hawaii.

April 4, 5, 6, or 7th, 1932 (?)

Letter to Hanns Skolle, written as much to pass the time
as to convey greetings, exchange sentiments, and the like.
For here I am afloat in a vast salt ocean and have been,
for one month now, without having seen nothing but a ex-
asteratingly circular horizon which in itself is too big
to see all at once. Not that I would want to.
The annoying thing is that this spacial emptiness grows
within. Thus I perish. And perish alone. For who and
what are my companions other than images off a printed
page, or out of a chaotic memory and a constipated imagin-
ation? I shrink from describing to you the flesh-and- blood
sharers of my fate. Your sensitive ear. You are familiar
with the gulfs that yawn on occasions such as this. Lord
help us, are we the only people in the world? The Jane
Brewer has born a man-child, the fool. I hope he will be
stupid and thickskinned, and kept out of my sight. Where
will I go? Maybe to Europe since the fare has been reduced
to 125 dollars for the round trip. But only for a short
time, to try to do something with photographs. New York
is probably in total crash by now; must be absolutely nothing
going on there, judging from the state of affairs when I
left three months ago. Great guns I have been on this
rocking peanut since the first day of January. Happy New
Year. Have you ever read Thomas Hardy? Jude the Obscure;
The Return of the Native. But especially Jude the Obscure.
Have you ever read War and Peace? Have you ever read - well
let that drop. There are lots of books on this here boat.
The captain is crosseyed. I have tried drinking, staying
up all night, painting in watercolor, climbing to dangerous
heights in the rigging - in short, everything but masturbation
Hasten to add that of the two ladies present only one is
attractive to me and she is in love, rather spiritually, with
our host. Oh yes I have also tried playing jazz records on
the victor. Don't ever try that if your'e cooped up in a
small escapeless place. The tune begins the next morning
in your head and continues with the rythm of the engines
for from thirteen to sixteen days running, at the end of
which time you jump overboard (tomorrow).
The was nothing much to the South Sea Islands. Exotic yes
for a day or so, and I suppose living there would be a lit-
tle pleasanter and a little easier than in a American or
a European city, but there can't be much choice, and if there
were even, I'd choose the American city. For because there
is nobody to talk to in the South Sea Islands and nobody to
do evil and diverting and stimulating and diverting things
with. And it is too hot and bad food and venereal disease
and rain. Apparently life is just awful anywhere, as someone
has said.
Queen Victoria by Lytton Strachey is a clever book. Indeed,
the English are a wonderfull little people. The crew's
messboy has got a small cockroach in his ear, and although

the cockroach is dead, the messboy is in pain, and will
be until we get to Panama, eight days off. For some
reason or other I am all right in health but I can no
longer eat hardlt anything, my teeth are all loose in
their sockets, sleep at night is out of the question,
and my stomach is permamently nauseous.
Now what news will I have of you upon my de retour
about April 25th? If you have come to New York Island
before me you have been imbecilic. And if not you have
probably committed suicide in the south of France, A.-M.
As for this girl I said was on board with me she is good
comic relief to hear her laugh and get tight and dance
and see her roll on the floor, but she is a nice girl.
Sometimes we all dance and roll on the floor because there
are soft carpets and wee are way out in the ocean with
a certain sense of isolation, as it were. And there is
much jealousy and sometimes she likes me because I am all
wrong but have an interesting mind while she is unhappy
in the love affair mentioned and she is proud in suffering
and I discovered it with my intuition. Now we can talk
about love late at night in her cabin or bunk and eat
crackers and use our intuitions on the others, who are
all unhappy too. Thus we uncover and analyse cruelties
and heartaches and dark unmotivated surprises in our com-
panions, some of whom are married but not living, I mean,
not going to bed together ocasionally. And small wonder,
for the husband is really incapable of going to bed with
his wife, she stinks and has too mush ego and is Spanish
anyway. And he doesn't want to in the beginning owing to
shall we say psychological deformities of a unmentionable
nature. The 1st steward too is a fairy but is not prosper-
ing. Also there has been a fistfight in the crew over a
game of checkers or perhaps for some deeper reason. Mutiny
is not thought probable but I don't see why unless they
realise that someone has got to make the ship go on, and we
in the poopdeck certainly couldn't. Navigation and steer-
ing a ship and manipulating the sails by the way is quite
a respectable job, and very cleancut too, but probably
tedious like all jobs. There are books about ships too
and how to run them, which I read mentally sometimes. A
ship would be exciting in a storm but we have no storms.
Everyone is thinking of leaving ours at Panama, and taking
a fast steamer to New York, because we are a month late
behind our plan to be h me April 1st. But I don't think
we'll do this. I at least would stay on and eat with the
Captain and chief engineer although frantic with boredom.
Well I habe been writing quite a letter and you will be
tired of reading my letter if I don't look out. Well I
could now stop and typewrite this letter which you couldn't
elsewise read on account of the peculiar script.
Do read Jude the Obscure but be careful, it is depressing
like hell - worse in that respect than Russian nihilists
like Chekhov and Dostoevsky, and visionaries like Ring Lardner
Kind regards, Walker Evans.

Unknown Photographer, [Walker
Evans and Unidentified Man Aboard
the *Cressida*], 1932, 13.5 x 17.8 cm
The Metropolitan Museum of Art,
Anonymous Gift 1999.246.43

Walker Evans to Hanns Skolle

New York City to Europe
Excerpt
May 19, 1932
Manuscript
WEA 1994.260.25 (35)

This is Evans's first letter to Skolle after returning to New York City after four
months in the South Seas. The Depression had significantly deepened while
Evans was abroad, especially in industrial cities like New York. Despite Presi-
dent Hoover's efforts to address the country's needs with federal funds, Con-
gress failed to pass his initiative and to authorize federal relief efforts. Final-
ly, in May 1932 at precisely the time of this letter, the "Emergency Relief Act
of 1932" was passed, supplementing local relief efforts with 300 million dollars
in federal loans to the states.

H.—

I have been back in New York for three weeks. Found two letters from you upon arrival. And that's about all I found. I mean to say, I mean to say this city is offering a spectacle of disintegration such as has never been equalled. So the first thing I want to impress upon your ever acute consciousness is Don't come to America. That is if you are the same sort of person you were when you left it. If you are still an individualist and an artist and a human being and a man of character, and if you can live in Europe, stay there. However if you care now to go to pieces and to see all your friends doing the same you could come over here and sponge off a few crumbs dropped by our still oversupplied upper crust; do what you are told to do; O.K. come ahead. Then when the time comes for the upper crust to crack you can at least enjoy the sight of anguish suffered where it should be.

I am beginning to understand what sort of a period we are living in. Now I am thrown on my own resources (which thank heaven are something at present, through photography). There is nothing to be done but go after money by the nearest means to hand. For instance I have "contacts" and "leads." People in such bastard trades as advertising, publicity etc. have sometimes heard of me because I have given two exhibitions of photos. So I may get a job. I may make photo murals for Bloomingdale's store or I may make theatrical posters for Roxy's theatre. As they want them, of course; not my way. Also I brought back some few thousand feet of film from this South Sea trip, through which I may break into something. The film by the way is good in spots. That is, there are a few irrelevant shots that are beautiful and exciting in themselves. What can be made out of the whole thing remains to be seen. If I can sell the whole works to movie people, I will, of course. If not, I'll try to make something short and original and then show it to the Guggenheim Foundation or Otto Kahn or anyone else who might help me go on and make some more. Movies as you know are very expensive. The materials for this

one I made came to $1000, paid for by the people who took me along. As I think of the situation at present I can't see anything I'd rather do than get you over here and make a really good film with you as collaborator. You remember the "Men Working" idea? Movies are more difficult than I realized. I seem to be able to get striking individual pictures but have difficulty in composing any significant sequence. Hard to dramatise my subjects. The technique is not especially difficult. Out there I depended a lot on color filters and telephoto lenses. I was really surprised the stuff came out into well taken pictures, have learned from this little experience that results *can* be gotten anyway, by my own hand. The thing is, I went in fear and trembling because I knew next to nothing about how to operate my machinery; and couldn't tell what I was getting until we got back to New York. Was so anxious about it all I couldn't write you until I knew what happened.

You will pardon me for this egotistical preamble. I will now answer your letters. Then perhaps tell you something about the trip.

Your writing is excellent, better and better. Read also a letter to Paul about desert sands. You have certainly been about with your eyes open. Mine were obscured and I'm sorry I let you down with muddy reactions. Find it more and more difficult to write, but painted at least one interesting watercolor on that trip. That of course I am very anxious to have you see. I must say I miss being in on a painter's work, your work I mean. As I remember it the birth of your pictures was giving me a lot, more than I knew. I see only Ben Shahn among painters now, and though he is much improved he'll never excite me as you did through painting. Ben hit upon a good thing for him this winter when he executed and exhibited a series of gouaches illustrating the Sacco-Vanzetti affair. They were extraordinary well done in an entirely new manner which I didn't think he had in is hand, and they sold well, bringing tremendous public attention. It all culminated in his nearly wrecking the Museum of Modern Art (now in its own building) by hanging a huge mural of Sacco & Vanzetti in coffins, presided over by the Lowell Commit-

tee holding lilies, almost photographic likenesses of President Lowell of Harvard and two other powerful gents who are naturally friends of the museum directors. Our friend Lincoln Kirstein had charge of the show and invited Ben to hang one mural along with about forty other Americans. It seems a big new two-block skyscraper development is in doubt about how to decorate its walls, so this show was supposed to be a hint and suggestions. The whole thing is a delicate capitalist confusion. Kirstein was badly damaged for insisting upon hanging Shahn's picture, so is now a hero. He (Kirstein) published a doubtful novel this winter, by the way. I won't send it to you, it's rather meaningless.

[…]

You and I will correspond furiously from now on, I will send some pictures of South Seas which by the way are nothing much I mean the pictures as well as the South Seas. Romantic journalism, the beautiful tropic isles, etc. but not up to my usual great work. Bank on the movies, we'll be rich yet, and probably interested in what we're doing.

You don't understand the awful bloodcurdling conditions I was travelling under, the sort of millionaire's joyride I was on. Conditions of the people, manners of the inhabitants, native craftmanship indeed. I was fighting (I hope) for my life and the wonder is I observed anything at all. Some day I'll detail the extraordinary personal situation I got into with those people. Of course I was able to notice that there just isn't any native craftmanship in the whole of the South Seas, that the natives can still sing and dance after a fashion sometimes moving, and that it would be impossible for me to live out there with any conviction at all. As I told you, I was sick, on top of other complications. You would be too, I suppose, although you like heat better than I do. Loneliness you don't like and that's the great trouble with the place. Polynesia *may* be a refuge if Europe and America go altogether to smash, but then I don't think I would want to go anywhere at all. I have really nothing to do that isn't somehow connected with and dependent upon

the Occidental spirit. Practically speaking, you could live in Papeete, or near there very much as you would live in any out of the way corner, but it's rather far to go for the same thing you would get in the West Indies or even nearer. If you want pure primitive contact you'd have to go elsewhere in the Pacific. I'm told some peoples are still living as they always have, but didn't see any. Those I saw are much more decadent than your New Mexican Indians, who at least dance religiously instead of for wine or money.

The last bit of news I have to offer is that Hart Crane did away with himself by jumping off a steamer in the Carribbean Sea last month. He was drunk, made a spectacular dive from crowded deck at high noon, was completely lost immediately, sharks probably, although boats were lowered and search lasted an hour. Had been unable to write anything in Mexico, where he went on a Guggenheim scholarship. Don't let this upset you, Crane was a goner long ago as you will remember.

W.

Walker Evans to Hanns Skolle

New York City to France
Excerpt
April 20, 1933
Manuscript
WEA 1994.260.25 (36)

"Harry Hopkins": Hopkins was one of President Roosevelt's closest advisors. After his inauguration in January 1933, Roosevelt convinced Congress to authorize the Federal Emergency Relief Administration (FERA) to which he appointed Hopkins as Director. Hopkins was a family friend of Evans's mother; it is interesting to note that Evans knew of Hopkins's pending role before May 12 when it was officially announced to the public.

[...]
Here it has been bad for a stretch but better now. But that was why I wasn't writing. What has happened is that I have been unable to get help when needed. Although my expenses are low they have had to be raised by any kind of work. Much better now, as I say, but I no longer think of *saving* money. America is really changing, though I don't think you'd like it any the better. At least, though, none of the cocksure prosperous ones are cocksure now. That's a great help psychically even though it means the almost complete disappearance of art patronage. May I add, fuck art patronage; it never was right when it *could* be lavish. There is some talk now of a state patronage under the guise of unemployment relief for artists. I do believe that would be more honest than the sort of racket of the prosperity period. It means less decorating of Park Avenue retiring rooms. Fortunately Harry Hopkins will have charge of this money and he has sense enough to ask people who know, how to manage it. When I first got wind of it I was apathetic but now I feel it might be really a good thing. Harry by the way has been designated as Federal relief commissioner by Roosevelt and if he goes to Washington might have a chance to do enormous things for artists. It's important because at the moment there is *nothing* doing; no artists even the best are working with any spirit at all. But enough of politics.
[. . .]

Yours infinitely W.

[Evans's Studio and Darkroom at 201 East 93rd Street, New York City], January 29, 1939, 9.5 x 12.1 cm

The
Negative
Archive

The Walker Evans Archive contains approximately 30,000 black-and-white negatives, 10,000 color transparencies, and copies of virtually all of the more than 2,600 SX-70 color Polaroid prints that Evans produced in the last years of his life. Evans's work with the camera includes almost every negative type available to a twentieth-century photographer from glass-plate negatives to nitrate motion picture film to 35-mm and 120-mm color slide film. It is rare in any artistic field that one of its greatest practitioners should leave to posterity his entire output. Using these resources, as well as the approximately 1,000 negatives by Evans now in the collection of the Library of Congress, Washington, we have the opportunity to map Evans's creativity in the most complete way.

In addition to the negatives, the Walker Evans Archive also contains a large set of papers which are related to the negatives including original negative sleeves, field notes, diaries, personal and professional correspondence, and subject research files for *Fortune* magazine projects. These related materials have been matched to their respective negatives and are therefore an invaluable guide for researchers interested in using original materials to order the work chronologically, and to study the artist's working methods. The negative envelopes and diaries show, for example, that in the 1930s Evans preferred working frontally with noonday sun for photographs of the facades of buildings, while at the same time he used early morning light for general views of small town streets. Likewise, the archival material sheds light on Evans's complex strategies for titling his photographs. Some images required specific city and state place names, for example, while others eschewed specificity for regionality such as *Garage in Southern City Outskirts*, a photograph actually made in Atlanta, Georgia.

Evans did not use any inventory numbering system to organize his archive, nor did he keep consistent records of how many negatives he made in

any series or for any job. Nonetheless, he kept, at times, extensive diaries and filed all his negatives in a variety of paper and glassine envelopes and put uncut rolls of 35-mm film in aluminum canisters. He typically stored the sleeved negatives in manila file folders in umbrella categories such as "SARATOGA, N.Y." or "ALABAMA CHURCHES AND SCHOOLS in cotton country, August, Sept. 1936."

Evans and his various assistants carefully annotated the individual sleeves with the photograph's title or descriptive title, and often the subject location, date, and negative format. He also often recorded specific information about the negative's exposure, time of day, camera lenses and filters used, and even noted printing instructions such as paper type. Some envelopes include drawings showing exactly what areas of the negative should be given increased or decreased exposure during printing.

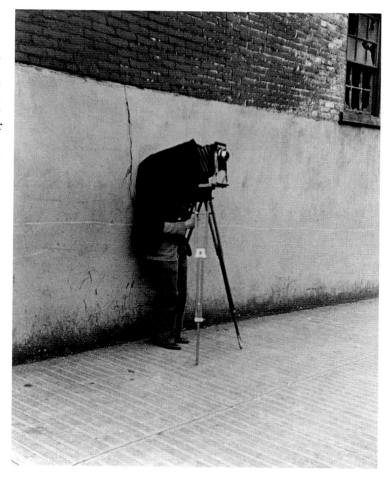

Peter Sekaer (American, born Denmark, 1901–1950), [Walker Evans Behind View Camera], 1935–37, 22 x 16.8 cm
The Metropolitan Museum of Art, Gift of Elisabeth Sekaer Rothschild and Christina Sekaer 1994.305.1

The Walker Evans Archive also includes numerous lists of photographs Evans selected for various projects. The earliest is one for Walter Goldwater, a Greenwich Village bookseller to whom the sometimes destitute Evans sold

books from his collection. Whether or not Goldwater actually took Evans's photographs to Russia and for what purpose remains unknown.

The negatives which Evans deposited with the Resettlement (later Farm Security) Administration and which are now in the Library of Congress, Washington, often treat the same subjects as those from the same years (1935–37) Evans kept for himself and which are now in the Walker Evans Archive. It is the nature of photography that each frame captures a discrete instant and that every picture is complete and different from all others. When the frames are exposed in close temporal or geographical proximity, the differences can be very slight. For this reason it is often mistakenly thought that the negatives deposited in Washington duplicate those retained by the artist. This is not the case. Comparing the two collections it becomes clear that from the very first day of work for the federal government in June 1935, Evans kept one or more negatives for his own archive for every one he delivered to Washington. With very rare exceptions these collections therefore do not replicate each other, they complete one another.

The following pages present several representative, but necessarily brief, forays deep into Walker Evans's negative archive.

SENT TO RUSSIA WITH W. GOLDWATER

1. Chrysler bldg. lower half
2. Bway lights composition
3. N.Y. Barge Canal Term. Grain elevator
4. Clothes on the line
5. Graybar rear
6. Kasbec service—Paratex walls
7. Brooklyn power house chimneys & clotheslines
8. Coney Island ferris wheel
9. Camels made for folks who etc
10. Baking powder lettering
11. Lucky-Strike—Hollywood Revue
12. Cars greased—socony gas
13. Fisk—U.S. Rubbers
14. Cork float
15. Workmens lunch hour—Qualitona enamel
16. 6th Ave. (negress)
17. Negro longshoreman
18. Union Square scene (Auerbachs)
19. Soldiers, Lindbergh Day
20. ” Byrd ”
21. Lovers, Coney Island
22. Four sportsmen, Danbury Fair
23. Group of bathers
24. Two men in caps, Bloomingdales
25. Quick lunch
26. Knickerbockers, Danbury
27. Traffic, Borough Hall
28. Three men in caps, Bloomingdales
29. Lady diver, Bronx signboard
30. Coney Island beach, larger group of bathers
31. Grain elevator Montreal, curved shadow
32. ” ” ” rectilingular composition
33. Lex. Ave. & 42nd from Chanin
34. Chrysler under construction, half steel
35. ” ” ” all steel
36. Commodore and Graybar, rear view

"SENT TO RUSSIA WITH W. GOLDWATER,"
Manuscript list, 1930, WEA 1994.250.4 (3)

Broadway, 1930, 26.9 x 23.3 cm
Collection of Alan and Gloria Siegel, New York
(# 2 on list)

[Chrysler Building Construction, From Roof of Chanin Building,
New York City], 1929, WEA 1994.255.24
(# 1 on list)

[Wonder Wheel, Coney Island,
New York City], 1929–30
WEA 1994.251.326
(# 8 on list)

Outdoor Advertisements [Times Square], 1929, WEA 1994.251.288
(# 9 on list)

[Signs, New York City], 1928–29, WEA 1994.251.54
(# 11 on list)

[Filling Station Detail], 1929–33, WEA 1994.255.55
(# 12 on list)

[Men in Caps, Bloomingdale's Construction Site, New York City], 1929–30
WEA 1994.251.317
(# 24 on list)

[Billboard in the Bronx, New York City], 1929–30
WEA 1994.251.343
(# 29 on list)

[Elevated Train Steps, New York City], 1929
WEA 1994.251.55
(# 10 on list)

[Industrial Landscape, New York City], 1929–30, WEA 1994.251.398
(# 3 on list)

[Coney Island, New York City], 1928–29
WEA 1994.251.167
(# 21 on list)

Traffic, New York City, 1929, WEA 1994.251.34
(# 27 on list)

West Virginia Living Room [Vicinity Morgantown], July 1935, WEA 1994.258.374

[Two pages from Walker Evans's 1935 diary], July 9–10, 1935
WEA 1994.250.97

Alice Davis the Quaker Friend. Curious
intelligent, courageous, little batty, alto-
extraordinary. Morning going around town
and photographing some interiors. Rather
discouraging, not getting much. After lunch pre-
sent at meeting betw. Davis and committee of
miners, subject starvation. Me fascinated. Miners
excellent. Witnessed also some rough stuff about
discrimination against negroes. To Reedsville PM,
letter and telegram saying do another project,
Westmoreland. Back to Morgantown, cabin of
night, for cash tomorrow.

Morning again watching Alice Davis'
Morgantown Relief Circus. Got away at noon
for Mt. Pleasant through Carnegie, Frick, Mellon
coal country. Arrived Westmoreland project
of homesteads late afternoon, took views
of houses, long talk with one Andrew Dzambo,
Czech miner, union officer and politician. Put in a
company boarding house, Frick mine Hecla #1.
After dinner Dzambo took me down into a
mine. Cold and terrifying. Dzambo hot air but
occasional information.

Morgantown

Tuesday, July 9, 1935
190th Day—175 Days to Follow

Early to Alice Davis the Quaker
Friend. Curious woman, in-
telligent, courageous, little
batty, altogether extraordinary.
Morning going around town
seeing and photographing some
interiors. Rather discouraging,
not getting much. After lunch
present at meeting betw. Davis
and committee of miners, subject
starvation, me fascinated. Miners
excellent. Witnessed also some
rough stuff about discrimination
against negroes. To Reedsville PM,
letter and telegram saying do

Hecla mine # 1, Southwest PA (Mt. Pleasant)

Wednesday, July 10, 1935
191st Day—174 Days to Follow

Morning again watching Alice Davis'
Morgantown Relief Circus. Got
away at noon for Mt. Pleasant
through Carnegie, Frick, Mellon coal
country, arrived Westmoreland project
of homesteads late afternoon, took view
of houses, long talk with one Andrew
Dzambo, Czech miner, union officer
and politician. Put in a company
boarding house, Frick mine Hecla #1.
After dinner Dzambo took me down
into a mine. Cold and terrifying.
Dzambo hot air but occasional
information.

MRS. BURROUGHS

 (near Moundville Ala.)

August 1936

8 x 10

FSA duplicate negative

PRINT DATA

Willow machine

25 W.

6 or 7 sec

use mask 1 sheet mounting tissue

Cut like this, for forehead:

[Allie Mae Burroughs, Hale
County, Alabama], August 1936
WEA 1994.258.425

[Negative Sleeve for "Mrs. Burroughs"], late 1930s, manuscript, WEA 1994.258.425a

[Negative Sleeve for "Mr. and Mrs.
Fields"], August 1936, manuscript
WEA 1994.258.309a

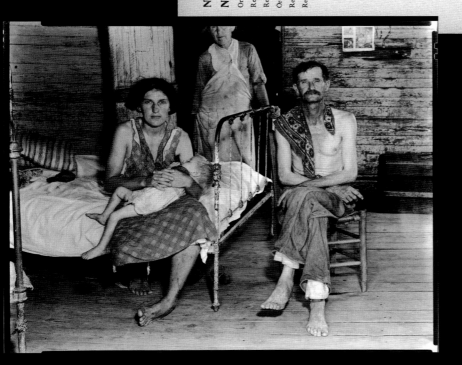

MR. AND MRS. FIELDS
August 1936
8 x 10
FSA duplicate negative

PRINT DATA
mask the Mrs. Fields half of neg.
with single sheet EK mount tissue
Azo #5
Willow machine
75 W
1 sec.
dev. W5, 1 to 1

[Lily, Lilian, and Bud Fields with "Miss Molly," Hale County, Alabama], August 1936
WEA 1994.258.309

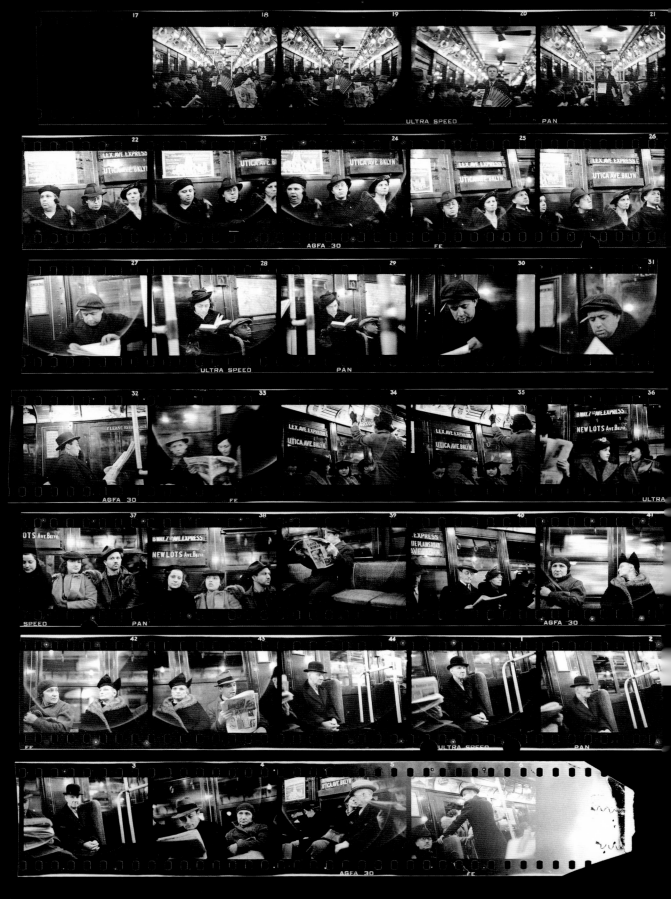

[Subway Passengers, New York City], February 25, 1938, consecutive 35-mm negative strips, WEA 1994.253.510-516

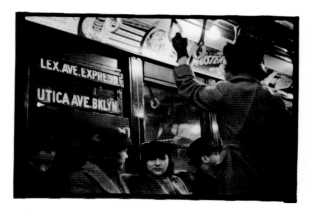

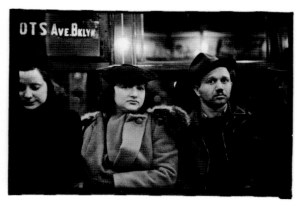

[Subway Passengers, New York City], February 25, 1938 (Frame 34), WEA 1994.253.513.3

[Subway Passengers, New York City], February 25, 1938 (Frame 37), negative margin punched for printing and captioned on the negative sleeve, "Brooklyn Youth" WEA 1994.253.514.1

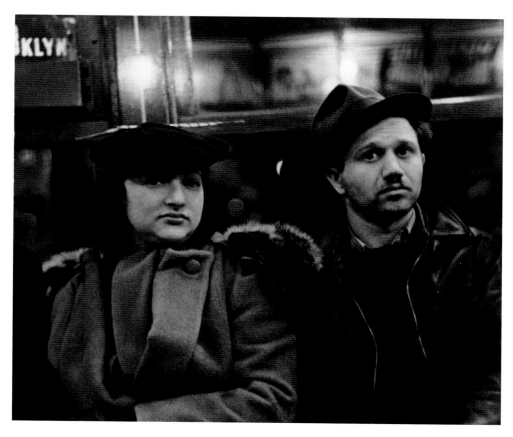

[Subway Passengers, New York City], 1938, published in *Many Are Called* (Boston: Houghton Mifflin, 1966), p. 119, National Gallery of Art, Washington 1988.56.39

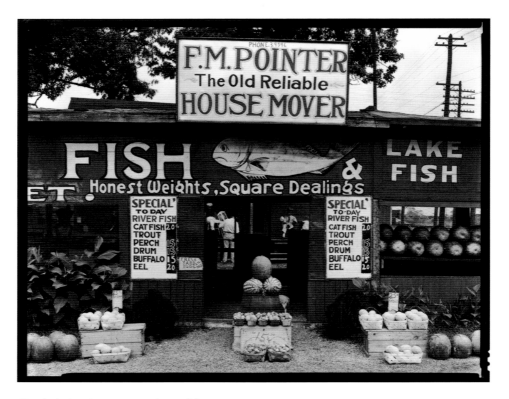

[Roadside Stand near Birmingham, Alabama], 1936, WEA 1994.258.215

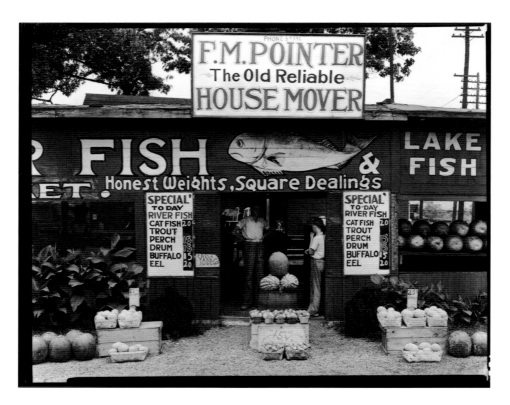

[Roadside Stand near Birmingham, Alabama], 1936, WEA 1994.258.278

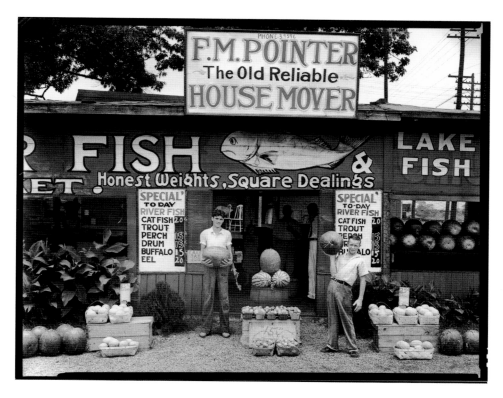

[Roadside Stand near Birmingham, Alabama], 1936, WEA 1994.258.430

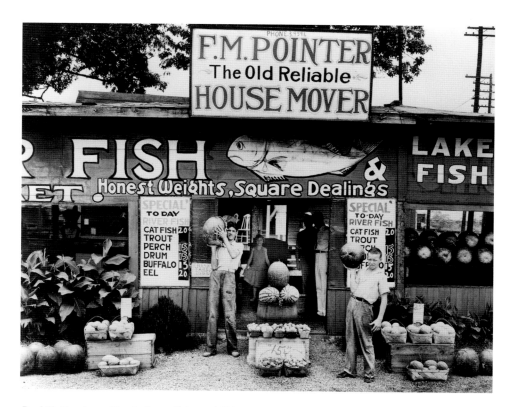

Roadside Stand near Birmingham, Alabama, 1936, Library of Congress, Washington, D.C. LC-USF342-8253A

Labor Anonymous

In August 1946 Evans traveled to Michigan to photograph the Ford River Rouge Plant. While he was there he produced what is probably a self-assigned series of images of city dwellers in transit. Evans positioned himself on a street corner facing a blank wall in downtown Detroit and made pictures of pedestrians as they passed before his lens. Evans's earlier photographs of subway passengers were made underground and undercover, and unconsciously recorded the claustrophobia and anxiety of a nation caught between the Depression and World War II. In this series, however, Evans exposed his procedure to the light of day, fixing on each of his subjects' signature gaze, gait, and gesture in the open and for the record.

For the project, Evans used a Rolleiflex camera which operated with a waist-level, ground-glass viewfinder and 2¼ in. roll-film. The photographs clearly reveal the lower-than-eye-level gaze that is characteristic of pictures made with such a camera. Evans, however, used this slightly awkward camera to his advantage. He first framed the scene, gauged the exposure, and preset the lens's focus. Then he simply waited for pedestrians to pass by a predetermined position on the sidewalk. "Hiding" close to his body at his waist was the camera which he did not need to put to his eye.

The negatives show that Evans's conceptual strategy was successful and that the pedestrians remained unaware they were being photographed—although many of his 150 subjects took the opportunity to stare at the curious man standing on the corner, few altered their natural expressions except to turn their head. Several of his proposed working titles for the article such as "One street corner, one afternoon, 24 people" further emphasize the serial structure behind this process. So, too, does Evans's Whitmanesque list of evocative tradesman names and its quotidian corollary, the classifieds clipped by Evans from the local newspapers.

Fortune published "Labor Anonymous" in November 1946.

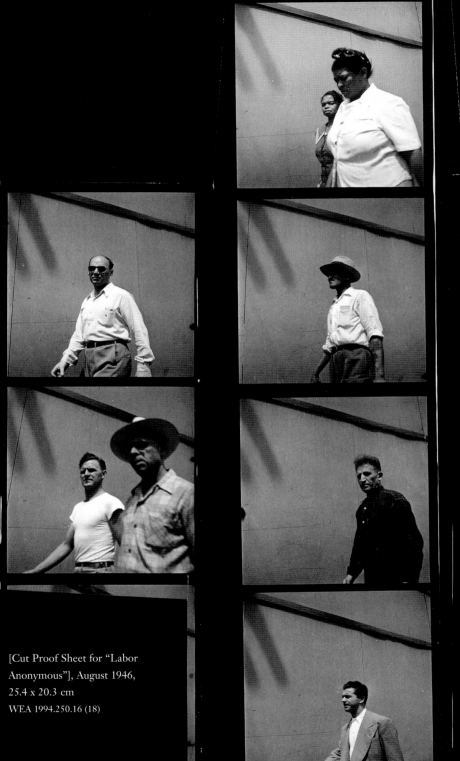
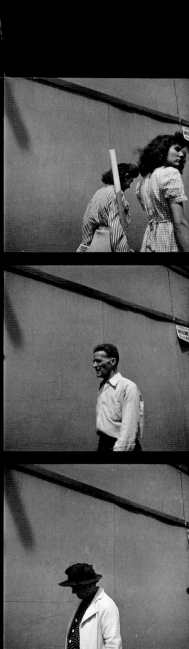

[Cut Proof Sheet for "Labor
Anonymous"], August 1946,
25.4 x 20.3 cm
WEA 1994.250.16 (18)

millwrights
watchmen
graders
patternmaker
joiners
plasterers
glaziers
platers
chasers
touchup men

spot welders
roofers
setup man
spotter
woodturners
burners
bacteriologists
pickers, sorters
copywriters
detailers
comptroller
craters

[Project Notes for "Labor Anonymous"], 1946
manuscript on verso of Time Inc. stationery
WEA 1994.250.16 (13)

[Project Ephemera for "Labor Anonymous"],
August 28, 1946, newspaper clipping
WEA 1994.250.16 (13)

[Unused Titles for "Labor Anonymous"
on 8 x 10 in. Negative Sleeve], 1946, manuscript
WEA 1994.250.16 (3)

Photographic rendezvous with 24 working people
One street corner, one afternoon, 24 people

24 people exchange glances with a camera
A silent exchange of glances with 24 workers

Cast of characters in an industrial city, 1946
A 1946 cast of caracters in an industrial city.

Labor Anonymous

These people walked by a carefully planted camera one afternoon in downtown
Detroit last month. None posed, few knew they were being photographed.
FORTUNE prints their images—with thanks to them for serving this visual pur-
pose—as a cross-section view of average hard-working people. The pictures
remind you that "Labor" portrayed as a grinning—or groaning—colossus is now a
very dated caracature indeed.

Machine-oilers or stock-runners, truckers, loaders, or short-order cooks pass
you here. Some may be worried, some just blank in the smooth waters of prosperi-
ty. All are—at a safe guess—your anonymous producers.

[Unpublished text by Evans], typescript, WEA 1994.250.16 (7)

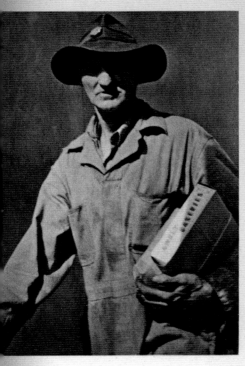

Labor Anonymous

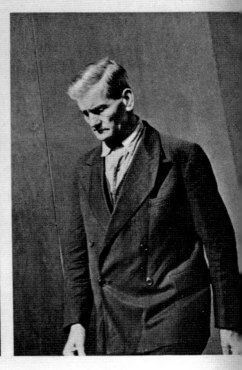

ON A SATURDAY AFTERNOON IN DOWNTOWN DETROIT

The American worker, as he passes here, generally unaware of Walker Evans' camera, is a decidedly various fellow. His blood flows from many sources. His features tend now toward the peasant and now toward the patrician. His hat is sometimes a hat, and sometimes he has molded it into a sort of defiant signature. It is this variety, perhaps, that makes him, in the mass, the most resourceful and versatile body of labor in the world. If the war proved anything, it demonstrated that American labor can learn new operations with extraordinary rapidity and speedily carry them to the highest pitch of productive efficiency. There may often be a lack of the craftsmanly traditions of the Older Worlds, but the wide spectrum of temperaments rises to meet almost any challenge; in labor, as in investment portfolios, diversification pays off.

Another thing may be noticed about these street portraits. Most of the men on these pages would seem to have a solid degree of self-possession. By the grace of providence and the efforts of millions, including themselves, they are citizens of a victorious and powerful nation, and they appear to have preserved a sense of themselves as individuals. When editorialists lump them as "labor," these laborers can no doubt laugh that one off.

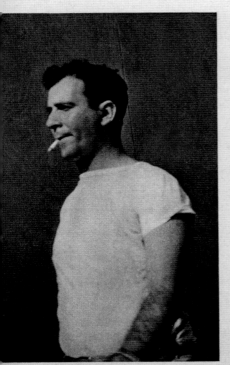

"Labor Anonymous," *Fortune*, November 1946 [text not by Evans], pp. 152–153

Color

In 1945 Evans took a full-time position as Special Photographic Editor at *Fortune* magazine, where he had been illustrating articles periodically since 1934. One feature that made the job worthwhile were the twice-a-year portfolios—combinations of image and text—over which he maintained complete control from the initial idea to the final layout.

During the next two decades, Evans produced dozens of photo stories for *Fortune*, most of them in color. Although he liked to say (in a stage whisper) that "color photography is vulgar," he used it frequently in these portfolios, in part to distinguish his pictures from the black-and-white of photoreportage that surrounded it. To separate his color from the garishly oversaturated hues of liquor and automobile ads, Evans restrained his palette, working in the belief that "if you tone it all down it's just about bearable."

At the end of his life, Evans created another very different kind of color photograph after being introduced to a new camera just on the market, the SX-70 Polaroid. A well-designed instrument for amateurs, the Polaroid was a point-and-shoot camera that produced a print instantly. In the space of barely a year the artist produced over 2,600 photographs with the little SX-70—portraits, lush color studies, and near abstractions. Partaking in an eleventh hour communion with the world (he had cheated death in the previous year), Evans used the Polaroid as the aging Matisse had wielded his scissors and brightly colored paper, creating the most distilled, potent expression possible of pure visual pleasure using the simplest of means.

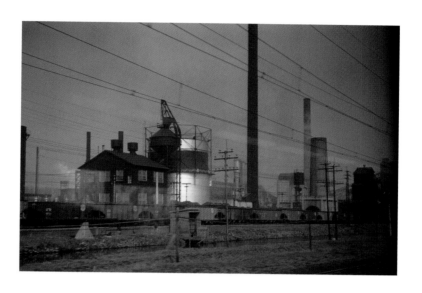

[Views from the Train, for "Along the Right-of-Way"], *Fortune*, September 1950,
unpublished 35-mm transparencies, WEA 1994.259.3

[Views from the Train, for "Along the Right-of-Way"], *Fortune*, September 1950,
unpublished 35-mm transparencies, WEA 1994.259.3

[Railroad Cars, for "Before They Disappear"], *Fortune*, March 1957,
unpublished 35-mm transparencies, WEA 1994.259.11

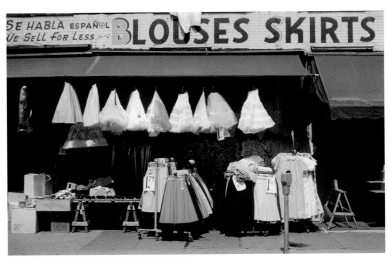

[Sidewalk Displays, for "The Pitch Direct"], *Fortune*, October 1958,
unpublished 35-mm transparencies, WEA 1994.259.13

[Caroline Blackwood], 1973–74

[House], 1973–74

[Table], January 19, 1974

[Snuff Sign, Alabama], October 1973

[Sign Lettering Detail], August 12, 1974

[Railroad Car Sign Lettering], September 16, 1974

Instant color prints, 7.9 x 7.8 cm, The Metropolitan Museum of Art,

Purchase, Samuel J. Wagstaff Bequest and Lila Acheson Wallace Gift, 1994.245.147, 135, 96, 41, 31, 107

STATE
CAPITOLS

FLATIRON

SUMMER
HOTELS

PERSONS

FACTORIES

AUTOMOBILES

STREET
SCENES

Collec-
tions

Walker Evans rarely threw anything away. He started collecting postcards as a child and ended his years collecting driftwood, tin can pull-tabs, and roadside signs, a lifelong habit almost entirely dedicated to the vernacular. He amassed an impressive library, a provocative collection of printed ephemera, a correspondence of more than a thousand letters, as well as a smattering of paintings, photographs, and prints given to him by friends and students.

Front Street, Looking North, Morgan City, LA., 1929, postcard, photomechanical reproduction, WEA 1994.264

FRONT STREET, LOOKING NORTH, MORGAN CITY, LA.

5975-29

The Postcard Collection

The penny picture postcard came of age in the 1900s–1910s when Walker Evans was in grade school; it entered his aesthetic consciousness before any other cultural artifact of the period. Sold in five and dime stores in every small town in America, postcards satisfied the country's need for human connection in the age of the railroad and Model T when, for the first time, many Americans regularly found themselves traveling far from home.

Inexpensive, ubiquitous, and unprepossessing, postcards were as much a response to the success of the automobile as to postal deregulations of 1907 which allowed correspondence to be written on the address side of the card. By 1914, the craze had become a boon to local photographers as their black-and-white photographs of small-town main streets, local hotels and new public buildings were transformed into millions of handsomely colored photo-lithographic postcards.

[Morgan City, Louisiana], 1935,
WEA 1994.258.583

201

War Picture Taken at Fredericksburg, Confederates at Ruins of Railroad Bridge

War Picture Taken at Fredericksburg, Confede-rates at Ruins of Railroad Bridge, 1920s, post-card sent to Evans by Peter Sekaer, August 11, 1939, photomechanical reproduction
WEA 1994.264

Evans began his collection when he was ten years old. At that age the young connois-seur of the American scene probably delighted in them as youthful third-basemen enjoyed baseball cards. Later he also became entranced by the cur-sory messages written on the cards which he regarded as a kind of found poetry, underground and democratic. At some point he methodically classified and organized his 9,000 postcards into subject categories such as "Small Towns," "Summer Hotels," or "Railroad Stations." Examination of the origi-nal category divider cards reveals that virtually all of Evans's own photographs would fit comfortably into the filing system he conceived for postcards. The vernacular subjects—the simple, unvarnished, "artless" quality of the pictures, the generic, uninflected, mostly frontal postcard style—represented a power-ful strain of indigenous Ameri-can realism that directly influ-enced his artistic development.

Where All Men Are Equal, 1900s–1910s, postcard, WEA 1994.264.109

The symbiotic relation-ship between Evans's own art and his interest in the style of the postcard can be demon-strated with a photograph and postcard of the same decaying row of once elegant Greek

202

Revival warehouses on Front Street in Morgan City, Louisiana. The photograph dates from February–March 1935, the postcard from 1929. Although there is no proof that Evans owned the postcard before he set up his view camera in Morgan City, the similarity in vantage point strongly suggests that he did. The postcard may even have served as a guide both to the existence of this community on the banks of the Atchafalaya River two hours from Evans's base of operations in New Orleans, and to the best location for describing it. Both the postcard and Evans's photograph seem equally authorless—quiet pictures that record the scene with an economy of means and with simple respect.

Electric Chair, Sing Sing Prison, N.Y., 1900s–1920s, postcard, WEA 1994.264.109

In his youth Evans bought new cards from the local Kresge's and Woolworths stores, and he collected old cards from his friends and family. By the early 1930s his professional acquaintances knew he was an avid collector and sent him cards with messages such as, "Ain't this a honey?" By the 1940s, Evans even considered his postcard collection worth publishing. In May 1948 *Fortune* published "Main Street looking North from Courthouse Square," the first of three articles Evans wrote on postcards that included selections from his personal archive.[1] Late in his life when twice asked to lecture on his career in photography, Evans instead gave lectures—at Yale University and at The Museum of Modern Art, New York—entirely illustrated with postcards from his collection.

The following postcards are drawn from Evans's presentation at Yale University in 1964.

Cedar Point Boat landing, Sandusky, Ohio, 1900s, postcard, WEA 1994.264.109

In Front of Clubhouse, Goodall, Fla., During Automobile races, 1900s, postcard, WEA 1994.264.109

Front Street, Marquette, Mich., 1900s, postcard, WEA 1994.264.109

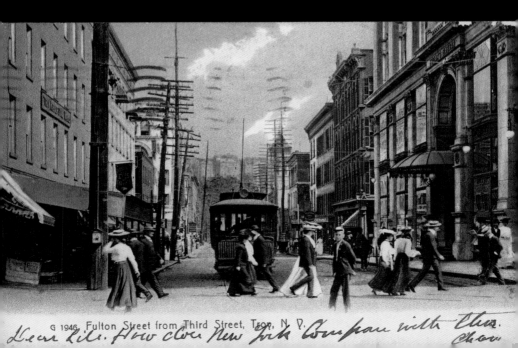

G 1946. Fulton Street from Third Street, Troy, N. Y.

The New Center.

Cleveland, Ohio.

The New Center, Cleveland, Ohio, 1900s, postcard, WEA 1994.264.109

2555—
Main St.,
Looking
South,
Hartford,
Conn.

Am having
a fine time
and hope
you & Marion
are too. Will
write you
soon.
I shall
return to
Nyack on
Thursday.
Love from
R.

Main St. Loo

Savannah, Ga., Bannon Lodge, Thunderbolt.

Savannah, Ga., Bannon Lodge, Thunderbolt, 1900s, postcard, WEA 1994.264.109

Poland Spring House, South Poland, Maine.

Poland Spring House, South Poland, Maine, 1900s, postcard, WEA 1994.264.109

The Picture File

Like many artists of his generation, Evans voraciously clipped and collected all kinds of imagery from the rapidly expanding picture press of the day. His collection contains reproductions of works of art, as well as engravings and printed ephemera depicting a wide variety of subjects. The file reveals, perhaps unsurprisingly, a predilection for picturemaking characterized by graphic simplicity and schematic pictorial construction: cave drawing, the paintings of nineteenth-century American limner artists, and the elegant line drawings and caricatures of Beardsley, Cocteau, Picasso, and Calder. Works created by the "untutored" eye and more worldly, dandyish depictions of modern life sit comfortably side by side in Evans's file, as exemplars of a purity that is stylish, and vice versa.

As a primitive means of mass communication, the informational engraving—with its unembellished look and primary status as document—exemplifies a pre-photographic way of seeing and recording that appealed greatly to Evans. The hundreds of engravings of zoological, botanical, medical, historical, architectural, and ethnographic subjects, some of which are mounted onto loose album pages, demonstrate the artist's fascination with "non-art" illustration, providing a usable model for Evans's own strategies of detachment and legible, objective description.

While Evans's preference for such engravings neatly parallels his own pared-down photographic style, the subjects in the picture file range far

beyond what we thought we knew about the artist's visual taste, as in the dozens of pictures he collected of embryos and fetal development. In the medical and anthropological engravings in particular, Evans was especially attracted to depictions of oddities and outsiders; such images probably appealed to Evans as rudimentary attempts to quantify and order that which is aberrant, foreign, or threatening. The tension between an inherently "cool" medium and a volatile, unruly subject reaches its apex in Evans's collection of Cuban news photographs depicting the chaos and bloodshed of the Machado regime and the ensuing revolution of 1933 (preserved by the artist as 8 x 10 in. copy negatives). By presenting such scenes of terror and violence second hand, already made over by the media, Evans could picture the kind of political and social turmoil that lurks offstage in his own photographs.

[Newspaper File Photograph of Corpse on Street in Cuba], 1933, WEA 1994.256.130

209

[Magazine Illustration of Jean Cocteau drawing of Picasso and Stravinsky], photomechanical reproduction, WEA 1994.250.90 (1)

[Reproduction of Drawing by Aubrey Beardsley], photomechanical reproduction, WEA 1994.250.90 (3)

Bild 7. Tiere im frankokantabrischen Stil. — Sie zeigen eine feste Form ohne Bewegung. Diese Stilart ist kennzeichnend für alle südfranzösischen und nordspanischen Malereien Zeichnung nach A. Breuil

[Book Illustration of Cave Drawings], photomechanical reproduction, WEA 1994.250.90 (2)

[Anatomical Drawing], undated, photomechanical reproduction WEA 1994.250.90 (15)

Calavera of the Female Dandy [Press Photograph for
"Posada—Printmaker to the Mexican People," an exhibition
at The Art Institute of Chicago, April 13–May 14, 1944],
gelatin silver print, WEA 1994.250.90 (5)

[Book Illustration of a Toilet], engraving
WEA 1994.250.90 (10)

[Book Illustration of the Brooklyn
Bridge], photomechanical
reproduction, WEA 1994.250.90 (4)

" To rush people through the air, across and around our city,"

Pictures of the Time

"A fair way of indicating to them why neither you nor I would give a fuck to work on the Magazine Proper would be to present for their looking-over your scrapbook as is, and my advertising and hate art similarly arranged."[2]

James Agee to Walker Evans, July 27, 1938

This bilious remark is the only direct reference to one of the most fascinating objects in the Walker Evans Archive. It is a thirty-three page, unbound album of pictures clipped from newspapers, pasted down without captions.[3] Agee's aside indicates that the "scrapbook" was unfinished but was a topic of current interest during the summer of 1938. Like *American Photographs*, published just two months later, Evans's unfinished album shows only images on the right-hand sides and is conspicuously lacking titles or personal commentary, except where the artist has chosen to keep the original captions attached.

One of the crucial facts about *American Photographs* is that all of its characters are anonymous citizens who are made, in the words of William Carlos Williams, "worthy in their anonymity."[4] There are no celebrities in the book, and where celebrity exists it is not in human beings but as a hollow condition—ghost images on torn, faded posters or billboards. If *American Photographs* is considered as a panoramic portrait of people and places not normally visible, then the scrapbook is its suppressed foil: an attack on celebrity, fame, and power. It is concerned almost exclusively with the wealthy and prominent, and with the construction and dissemination of images through the mass media.

The year 1937 was a particularly difficult one for both Evans and Agee, whose friendship was then at its most intense; their frustration with the corporate media system, symbolized by Agee's full-time and Evans's occasional boss, Henry Luce, finds its outlet in the satirical tone of the scrapbook.[5] In

1937 they had their article about tenant farmers in Alabama turned down by *Fortune* as unsuitable for the magazine, and Agee was rejected for a position at another Luce publication, the new illustrated weekly *Life*. In spite of being Luce's employees, both men despised the fawning adulation of big business and society seen in the pages of Luce's magazines, and particularly *Fortune*'s "Life and Circumstances" series, which patronizingly described how "small-town" Americans coped with the Depression. Through the scrapbook, Evans found his own novel way of redirecting his disgust with *Fortune* and the degradations of his medium in the name of journalism, as well as a way of venting spleen for having to work within the system that produces such corruption.

Throughout the late 1930s, Agee, Evans, and the filmmaker Jay Leyda had been plotting to create various kinds of alternative "documentary" projects involving the use of found materials. Late in life, Leyda told an interviewer: "He [Agee], Walker, and I were going to collect all kinds of documents: letters and papers that people dropped on the street, the last words of Dutch Schultz, things like that. Nothing ever came of it."[6] Agee had been thinking about such a project for quite some time, as when he wrote to his mentor Father Flye that he would like to undertake "a picture caption-chapter head history of the United States" that would be "extremely jagged and crazy ... mixture of lyric quotation ... statistic, and satire."[7] Although the contemporary reader might see this as an early appearance of appropriation art, Agee's unrealized projects using clippings and found materials were actually part of a craze for news photographs that swept Evans's circle during the 1930s (a passion that, for some like his friend the artist Helen Levitt, continues to this day). Earlier, Evans and his friend Hanns Skolle frequently included clippings in their letters; they constituted a kind of conspiratorial code, a way for like-minded souls to read and comment to each other on the hidden meanings of the world around them.

The subversive use of found materials that Agee envisioned in fact very much resembles the structure and tone of Evans's scrapbook. In Evans's version, New York City Mayor Jimmie Walker poses foolishly in Indian garb, the Duke of Windsor parades his wardrobe next to a trio of Skid Row types, and Franklin Roosevelt and a fellow politico belly-laugh above a pair of African tribesmen. The subtle, loosely poetic sequencing in *American Photographs* is here compressed into a series of screaming—and occasionally sophomoric—one-liners, often achieved through the provocative pairings of high and low, "civilized" and "primitive" images from the picture press. Evans's album contains clippings from the German illustrated magazine *Der Querschnitt*, which was known for similarly witty juxtapositions of photographs for satirical effect.

In addition to spoofing the vapid celebrity journalism of the period, Evans adds to the apocalyptic charge of the sequence by interspersing classics of photojournalism characterized by their unblinking depictions of violence and chaos: crew member Fred Hansen's off-kilter snapshots of the sinking of the S.S. *Vestris*, a blood-spattered New York City Mayor William J. Gaynor being led away from the scene of an assassination attempt, or Ruth Snyder, the first woman to die by electrocution, strapped to the electric chair. Probably triggered by Evans's and Agee's difficulties working within the Luce empire, the scrapbook is a highly explosive vision of human folly and madness— modern-day Bosch and Goya via rotogravure—created between the tail end of the Depression and the rapidly approaching next world war. It contains within it the vitriol too bleak and damning for *Life* and *Look*, and too loud for the quietude and melancholy of *American Photographs*, Evans's other depiction of a nation in crisis.

Since Evans's album pages are unnumbered, we do not know whether the order in which they came to the museum (as shown) was that of the artist.

Selections from *Pictures of the Time*, late 1930s, album of picture press clippings, WEA 1994.250.88

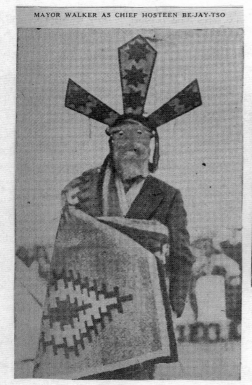

MAYOR WALKER AS CHIEF HOSTEEN BE-JAY-TSO

THREE AMERICANS WHO RECEIVED HONORS FROM POPE PIUS

Fleischmann's Yeast

INSIDE VIEW

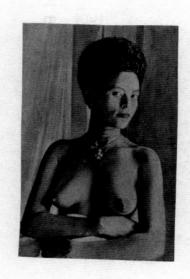

"I am the Law!"

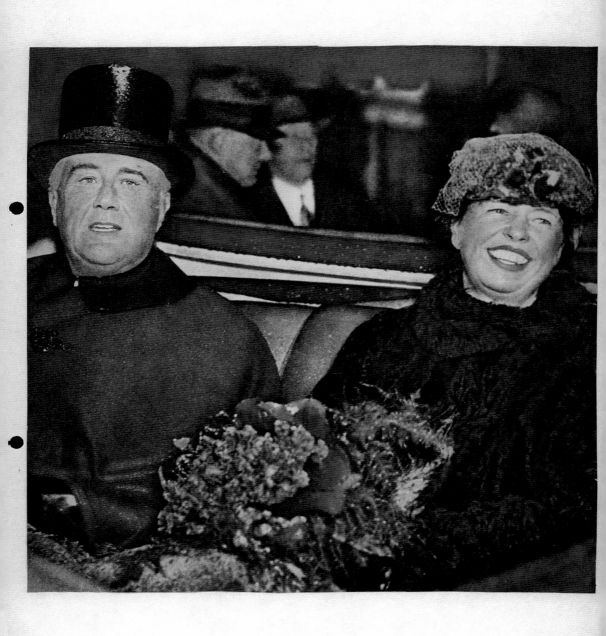

nthe, San Francisco 1906

Putting Their Heads Together on the Unemployment Problem

Times 3/17/29

You wouldn't care to meet Marvin

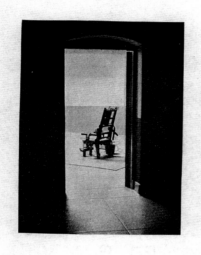 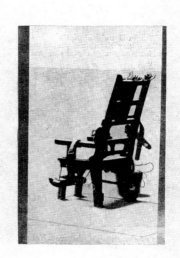

Average net 'paid circulation
of THE NEWS, Dec., 1927:
Sunday, 1,357,556
Daily, 1,193,297

DAILY NEWS

NEW YORK'S PICTURE NEWSPAPER

PINK EDITION

Copyright, 1928, by News Syndicate Co., Inc. Reg. U.S. Pat. Off. Entered as 2nd class matter Post Office, New York, N.Y.

Vol. 9. No. 174 28 Pages New York, Saturday, January 14, 1928 2 Cents IN CITY LIMITS | 3 CE Elsew

CROWDS Follow Ruth and Judd to GRAVE

—Story on Page 3

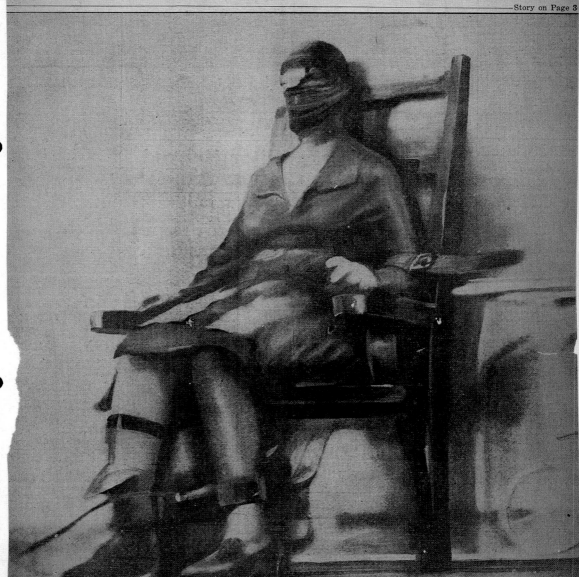

(Photos © 1928 by Pacific & Atlantic)

WHEN RUTH PAID HER DEBT TO THE STATE!—The only unofficial photo ever taken within the death chamber, this most remarkable, exclusive picture shows closeup of Ruth Snyder in death chair at Sing Sing as lethal current surged through her body at 11:06 Thursday night. Its first publication in yesterday's EXTRA edition of THE NEWS was the most talked-of feature history of journalism. Ruth's body is seen straightened within its confining gyves, her helmeted head, face masked, hands clutching, and electrode strapped to her right leg with stocking down. Autopsy table on which body was removed is beside chair.

—Story on p

Fliers Up 33 Hours at 8 o'Clock Despite Accidents to Plane—Page 2

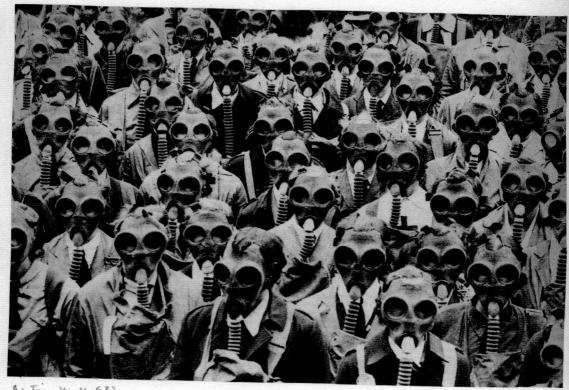

N.Y. Times May 26, p 37

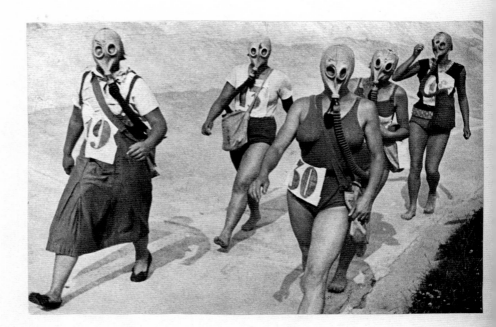

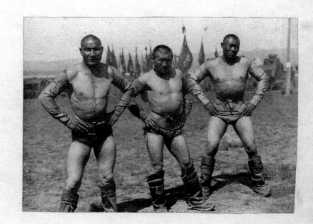

LA LOI DE LYNCH

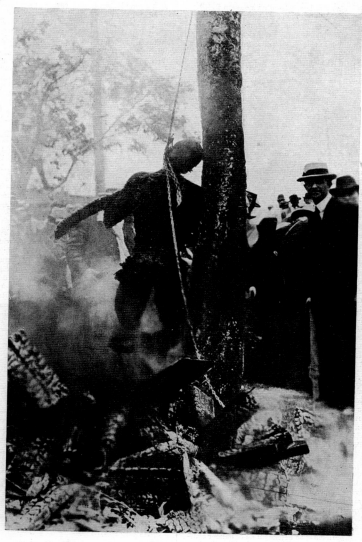

Un nègre pendu et flambé achève de se consumer
(Ce document nous a été aimablement communiqué par notre excellent confrère « Vu »)

BEAUTIFUL

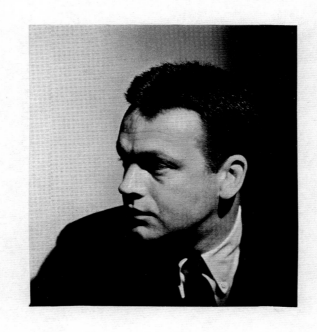

Life 11/30/36

As Antone Santos, hunted for assault with a knife upon Manuel Mello, was brought to police headquarters from a North End field where he was captured. The policemen, left to right, are Joseph A. Messier, Harry Fowler and Harry C. Hawes. Behind Santos is another of the searchers.

Assassinate President-Elec

Acme Photo.
This picture, reprinted from late editions of yesterday's World-Telegram, shows Giuseppe Zangara under arrest. At the left is Sheriff Dan Hardie and at the right Officer L. G. Crews holding Zangara's gun. Zangara has been stripped for search.

Notes pp. 24–117

1) H.L. Mencken, "Bring On the Clowns," from *A Second Chresto-mathy of H.L. Mencken*, New York: Vintage, 1995, p. 30.

2) E.E. Cummings, *is 5*, New York: Boni & Liveright, 1926; artist's personal copy, WEA 1994.264.3.

3) "Dancing Catalans. Reviewed by Walker Evans," in *Alhambra*, January 1930, p. 44; annotated carbon copy, August 1929, WEA 1994.250.3 (50).

4) See page proofs of Houghton Mifflin public relations brochure for second edition of *Let Us now Praise Famous Men* (1960); WEA 1994.250.75 (25).

5) WEA 1994.250.52 (79).

6) See WEA 1994.250.54.

7) See Mike Weaver, "Clement Greenberg and Walker Evans: Transparency and Transcendence," in *History of Photography*, 15 (Summer 1991), pp. 128–130.

Notes pp. 198–214

1) Evans subsequently published: "When 'Downtown' was a Beautiful Mess," *Fortune*, January 1962, pp. 100–106 and "Come on Down," *Architectural Forum*, July 1962, pp. 96–100.

2) James Agee to Walker Evans, quoted in Laurence Bergreen, *James Agee: A Life*, New York: Dutton, 1984, p. 222.

3) Evans's working title comes from a manuscript note in his papers: "Faces of the time // unidentified events of the time (news file) // the look of the time // customs of the time," " faces // customs // events // the look," "Pictures of the time // 1925–1935 scrapbook." The date range has been omitted because many of the clippings do not fall within it. WEA 1994.250.4 (24)

4) William Carlos Williams, "Sermon with a Camera," book review of *American Photographs*, in *New Republic*, Oct. 12, 1938, pp. 282–83.

5) Bergreen, op.cit., p. 222.

6) Lesley K. Baier, interview with Jay Leyda (May 23, 1980), quoted from unfinished manuscript for *Walker Evans: A Biography* by James R. Mellow, p. 550.

7) Agee to Father Flye, June 6, 1935, in *Letters of James Agee to Father Flye* (New York: George Braziller, 1962), p. 67.

Acknowledgments

In June 1994 The Metropolitan Museum of Art acquired all of Walker Evans's negatives and papers from his three beneficiaries—Virginia Hubbard, Dr. Charles Lindley, and Eliza Mabry—and from John T. Hill, executor of the artist's estate. We are greatly indebted to these individuals for their generous support of the Museum's initiative to provide a permanent home for the Walker Evans Archive. As soon as the archival materials arrived at the Metropolitan, an immense cataloguing and preservation project began—work possible only with the extraordinary support of a superb group of foundations listed on the next page who recognized the lasting value of the collection.

In the last five years a wide range of institutions and individuals have contributed valuable expertise to the effort to preserve, catalogue, and provide access to all the materials in the Walker Evans Archive. To all those named below and to others not mentioned here, the Department of Photographs expresses its deepest gratitude.

We especially thank for their tireless work Doug and Toddy Munson of the Chicago Albumen Works, Housatonic, Massachusetts who restored and duplicated Evans's deteriorating black-and-white negatives, allowing us to save them for future generations.

At the Metropolitan, many dedicated staff members assisted in every aspect of our work on the Walker Evans Archive and on this publication. We send our deepest appreciation to: Grace Brady, Barbara Bridgers, Jennie Choi, Susan Chun, Emily Rafferty, Bob Goldman, Ashton Hawkins, Nora Kennedy, Nina Maruca, Doralyn Pines, Tanya Savickey, Katya Shaposhnik, Eileen Travell, and Bruce Schwarz. For their commitment to the project and for their hard work, we also thank a superb team of museum fellows, interns, and volunteers: Rachel Carr, Leslie Taylor Davol, Shannon Fagan, Mia Fineman, Jay Gardner, the late Philippine Lambert, Zachary Lee, Lowell Pettit, Samantha Rippner, Anna Vallye, and Vivian Zelter.

Within the Department of Photographs, we owe a further debt to Maria Morris Hambourg, Malcolm Daniel, Laura Muir, Laura Harris, Predrag Dimitrijevic, and Mary Sanders, who provided welcome assistance and support for a myriad of details relating to the Walker Evans Archive and this anthology.

Jeff L. Rosenheim and Douglas Eklund
Department of Photographs
January 2000

The conservation of the Walker Evans Archive has been made possible through the generous support of the William Randolph Hearst Foundation as part of the Save America's Treasures program.

Additional conservation support has been provided by The Horace W. Goldsmith Foundation, the National Endowment for the Humanities, the Henry Nias Foundation, the Institute of Museum and Library Services, and The Andrew W. Mellon Foundation.

Jeff L. Rosenheim, Alexis Schwarzenbach (Eds.) — Unclassified: A Walker Evans Anthology

Design: Hanna Koller, Zurich
New digital photography: Bob Goldman and Tanya Savickey, The Photograph Studio, The Metropolitan Museum of Art
Scans: Gert Schwab/Steidl, Schwab Scantechnik, Göttingen
Printing: Steidl, Göttingen
Copyright © 2000 The Metropolitan Museum of Art. All rights reserved. No part of this book may be reproduced or utilized in any form or by any means, electronic or mechanical including photocopying, recording, or by any information storage and retrieval system, without the permission in writing from the Publishers or the Authors.

Publishers: Scalo Zurich—Berlin—New York
Head office: Weinbergstrasse 22a, CH-8001 Zurich/Switzerland,
phone 41 1 261 0910, fax 41 1 261 9262,
e-mail publishers@scalo.com, website www.scalo.com
Distributed in North America by D.A.P., New York City;
in Europe, Africa and Asia by Thames and Hudson, London;
in Germany, Austria and Switzerland by Scalo.

First Edition 2000
ISBN 3-908247-21-7
Printed in Germany